CRIEFF &
STRATHEARN
THROUGH TIME
Colin Mayall

AMBERLEY PUBLISHING

First published 2010

Amberley Publishing Plc
Cirencester Road, Chalford,
Stroud, Gloucestershire, GL6 8PE

www.amberley-books.com

Copyright © Colin Mayall, 2010

The right of Colin Mayall to be identified as
the Author of this work has been asserted in
accordance with the Copyrights, Designs and
Patents Act 1988.

ISBN 978 1 84868 279 5

British Library Cataloguing in Publication Data.
A catalogue record for this book is available from
the British Library.

Typeset in 9.5pt on 12pt Celeste.
Typesetting by Amberley Publishing.
Printed in the UK.

Introduction

Yet again I have put pen to paper to look into the changing pattern of life here in Strathearn. This new concept developed by Amberley Publishing has struck a real chord amongst residents and visitors to the many places already covered in this series and I trust that this one in our own backyard will create similar interest and discussion. The book has been arranged on a geographical basis. I have concentrated largely on Crieff and have been able to locate a sizable number of pictures old and new to include. This is not an in built bias against the other places in the Strath but simply that for a number of years I have become strongly aware that unlike Dunning, Blackford and Auchterarder, Crieff does not have a 'hands on' heritage or a local history group willing to organise and support local research. I sincerely hope that this will be remedied in the foreseeable future.

What has emerged in the preparation of this book is that whilst people change (unfortunately!) buildings or streetscapes in rural locations like Strathearn remain remarkably unaltered despite the passage of time. An exception to this is perhaps the type and location of the shops both in our towns and villages. Numbers have diminished dramatically in both size and kind and I trust that the pictures I have included will bring back more than a few happy memories. What transpired very clearly during the preparation of this book was the real extent and damage of the now notorious Beeching cuts of the 1960s when over 3,000 rail stations in the UK were permanently closed and some 4,000 miles of rail lifted The physical effect of this on the Strath has been considerable. It has not, I may say, all been totally negative. Resulting land regeneration has seen the establishment of a new hospital and health centre in Crieff, new pathways in Glen Ogle and between Crieff and Lochearnhead and tourist caravan parks at Comrie and St Fillans.

One of the most fascinating outcomes of researching this book, concerned the existence of an astronomical observatory at Ochtertyre

in the nineteenth century. With the kind permission of Mr Brian Souter and the help of local photographer and journalist Lynn Duke we located the site on the estate albeit that little remains of what was for many years truly unique in rural Perthshire. The picture showing the observatory and Sir William Keith Murray date back to the late 1850s. Despite the fact that photography as an art was in its infancy the quality and detail of the print is remarkable. Sir William died in 1861 and it is believed that the telescopes and astronomical equipment were donated to the Hunterian Museum attached to Glasgow University.

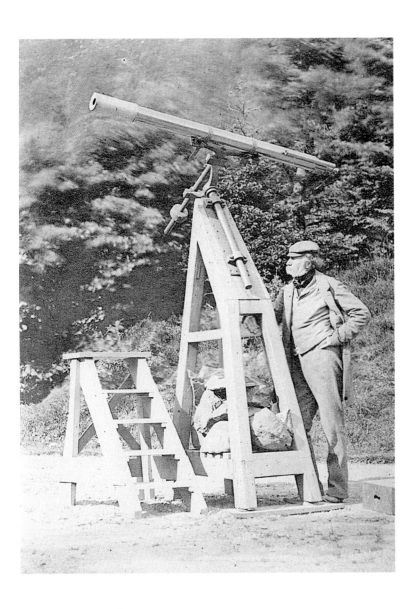

CRIEFF

62-64 Burrell Street

This typical terrace of Georgian houses was built in the aftermath of the last Jacobite Uprising when the Commissioners of the Forfeited Estates granted feus for the construction of dwellings to house the burgeoning number of handloom weavers in Crieff. This terrace housed as many as eight families on three levels. The social structure saw the better off on the ground level with the poorer ones living in somewhat squalid conditions and referred to as the 'garret folk'. The 1990s saw the building thrive for a period as The Highland Tryst Museum, an innovative and popular addendum to the town which sadly lasted all too briefly.

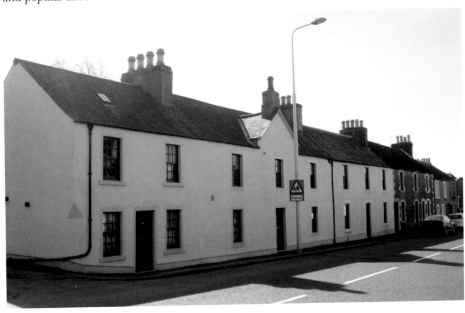

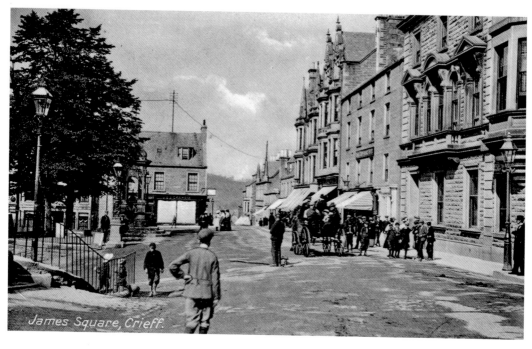

James Square, Crieff.

James Square (1)

The young chap with his back to the camera and gazing towards the horse-drawn carriage would, in this current age, be in danger of a rapid demise from the traffic pollution effecting the town centre! The Square has been transformed. Gone are the old lime trees and the Crieff Square Well, to be replaced by a multi-functional modern layout on continental lines which has become a focal point for town activities.

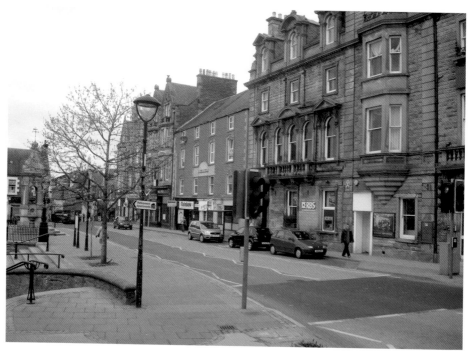

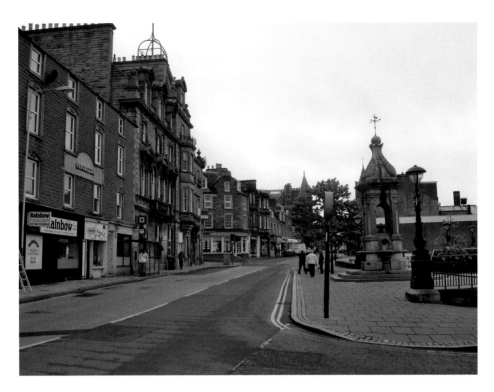

James Square (2)

Again one can see that the buildings in the two pictures are surprisingly similar. Both the temperance hotels adjoining the Drummond have gone, and are now flats and a Thai restaurant. The road to the east of the fountain is no more and traffic is a one way single access.

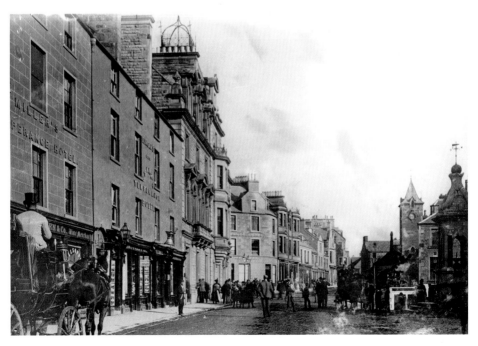

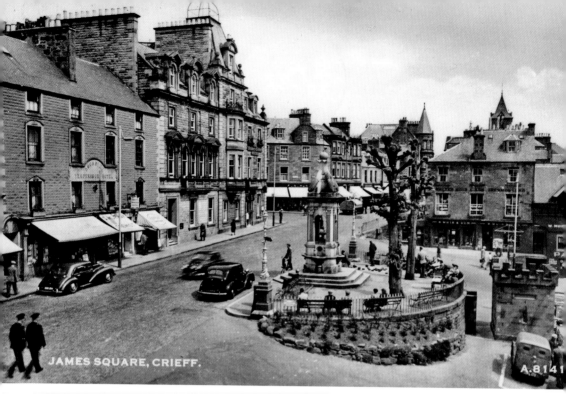

JAMES SQUARE, CRIEFF.

A.8141

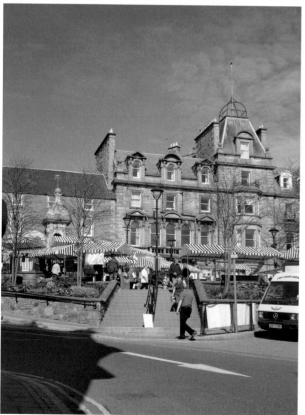

James Square (3)

The Farmers' Market held on a monthly basis has brought a real buzz to the Square as have the open air concerts on Games day and in the summer months. The buildings on the east side of the Square have changed radically. A fire destroyed what was Muir the Ironmonger's and the Royal Hotel to be replaced by a somewhat characterless building originally the William Low supermarket and now the Edinburgh Woollen Mill.

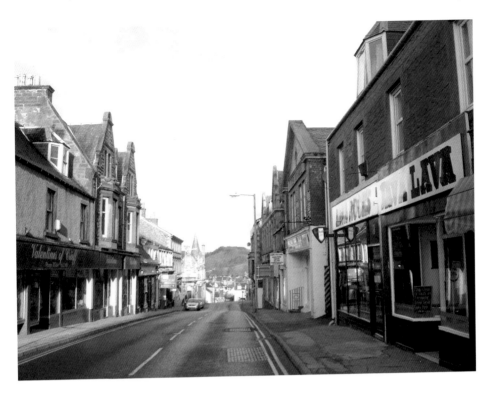

West High Street

The extension of the main road west heading towards Comrie. This was a street which housed several of the town's banks. Only the Clydesdale plc survives and the existing shops include Asian Carry Outs and a good choice of more traditional eating houses.

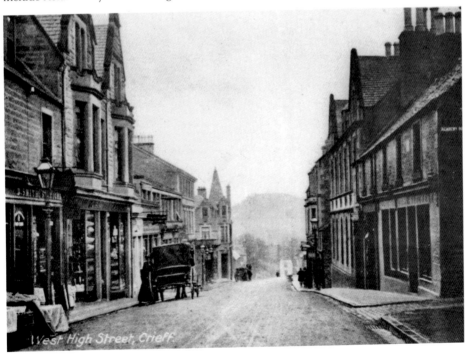

9

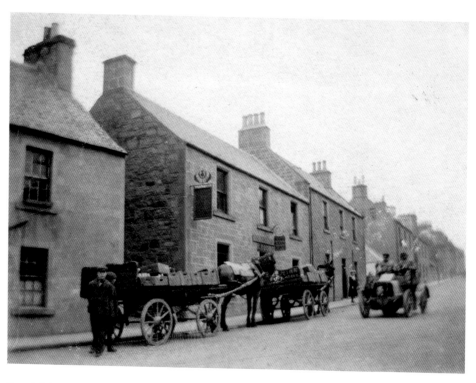

East High Street, Bairds Buildings
Bairds Buildings were built by the council to replace the older stone terraces that existed on the north side of East High Street. The picture shows the brewer's dray unloading supplies outside the Thistle Inn. The Crieff Poorhouse was located at the east end of what was to became the new flats.

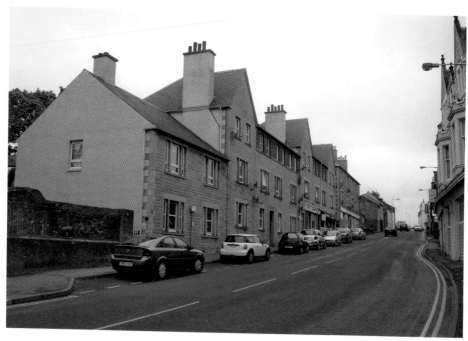

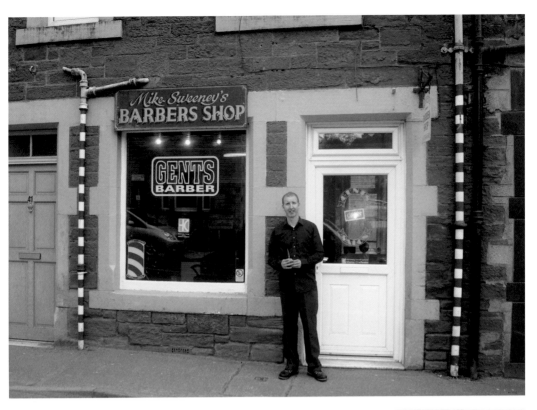

East High Street, Barber's

Mike Sweeney, barber, outside his shop in East High Street. This small shop has had many uses over the decades. The earlier picture shows Thomas Cuthbert (known as Graf) and his staff when it was a grocer's and general merchants prior to the First World War.

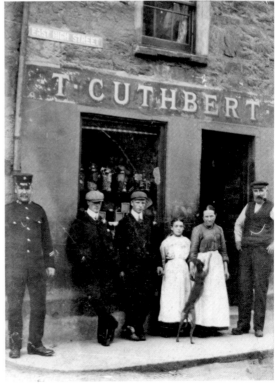

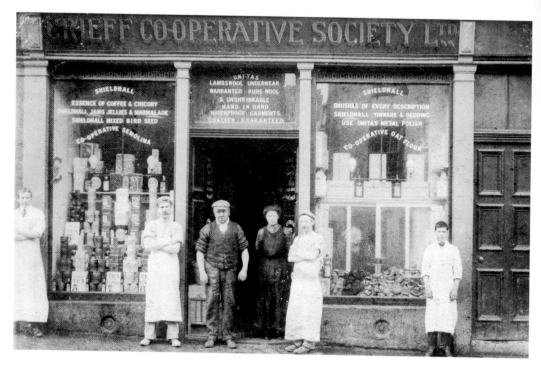

East High Street Crieff Sam Park's
This trendy hairdressing salon has replaced the old Co-operative Grocer's in East High Street.
Pictured outside the shop are Mr McKenzie the baker and Andrew Graham, the van man.

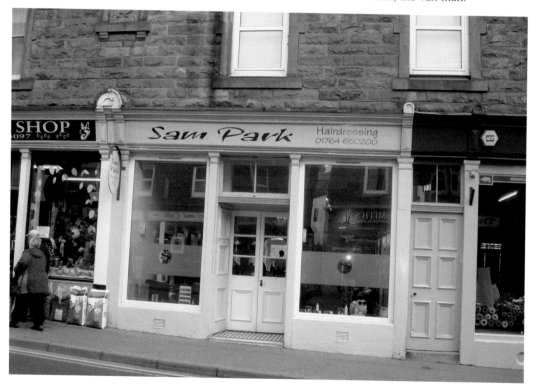

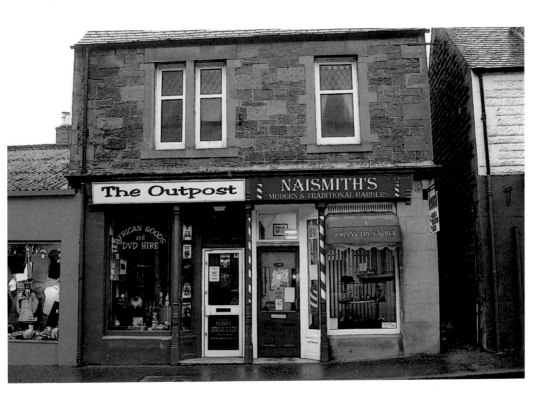

The Outpost and Naismith's

Dewars the Plumbers in East High Street can be seen below bedecked with bunting in celebration of the Coronation of George V. It is now split into two shops; Johnny 'the barber' Naismith and the innovative Outpost run by Fiona Gallagher and selling African goods and renting DVDs.

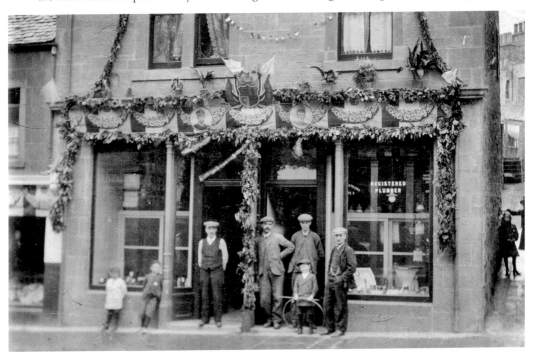

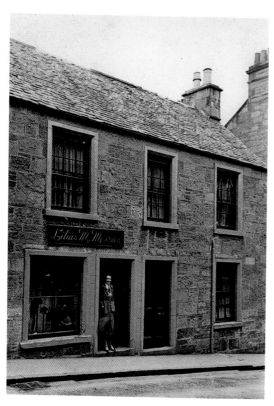

King Street, Lillias Menzies
Lillias Menzies, milliner of Crieff, had pursued a successful stage career prior to returning to the town. King Street once the principal artery from the station to the town centre has, since the demise of the railway, seen many of the smaller shops close and, in this case, turned into housing.

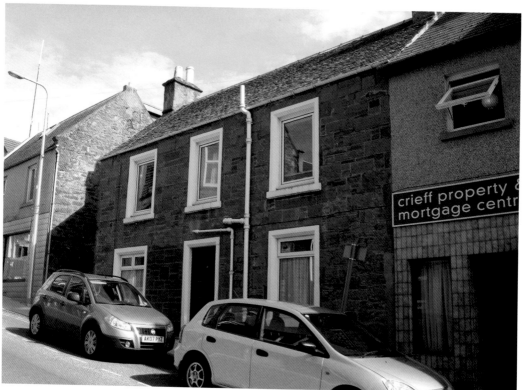

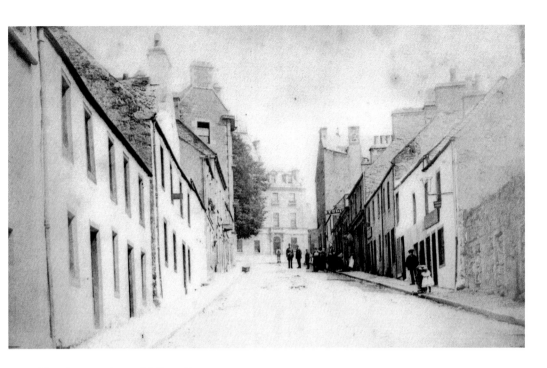

King Street, above Addison Terrace

The passage of time reflects the changes in this central part of the town. The Police Station is still Wright's Smithy. Wright's family crest has been preserved and can still be seen built into the wall above the bottom door of the modern building. The single storey roofless biggin is long gone, replaced by what was Brown's Fruit Shop and latterly McLeods Glaziers.

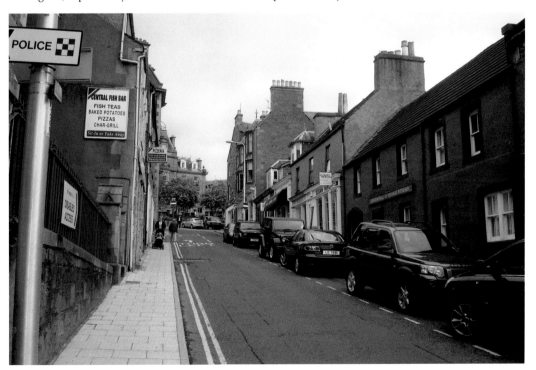

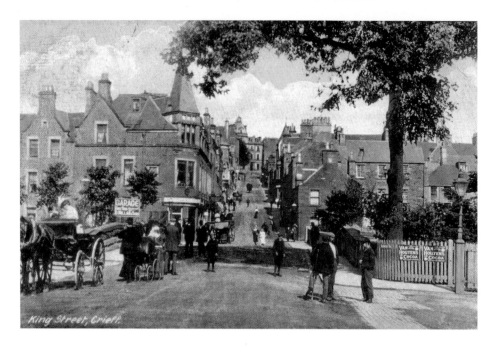

King Street, Railway Station

The station was for many years one of the most important locations in the town. Prevarication by the Town Council delayed the extension of the line westwards to Comrie. The Railway Company was one of the largest employers of labour in the Strath and the maze of sidings and sheds were a vital link in the economic infrastructure of the town sending out cattle and timber and bringing in coal and, importantly, tourists and holiday-makers.

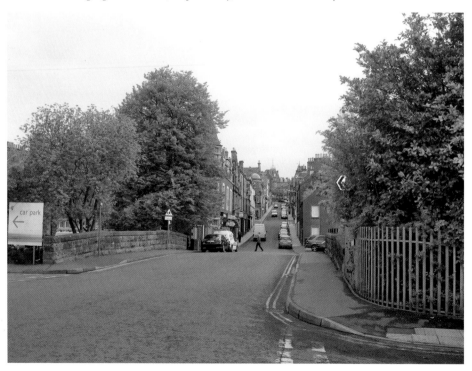

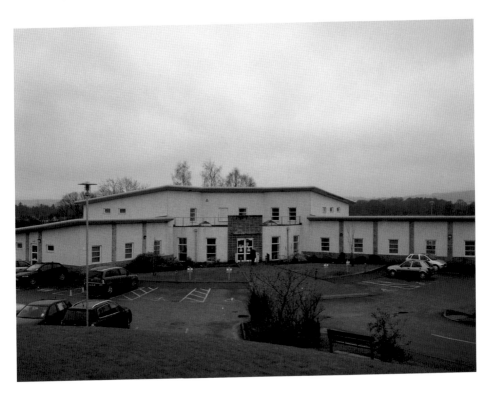

Health Centre

The Health Centre (Mark 2!) lies on the southern periphery of the old railway station complex. The mineral siding brought in supplies of coal for both domestic and commercial use. The railway at one time was the second largest employer of labour in the area.

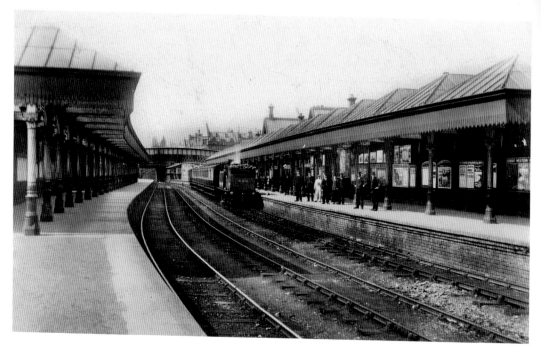

Ambulance Depot

Crieff Station was a bustling place both for passengers and goods. A considerable infrastructure was built up catering for the large and varying businesses. Most of these buildings have long since gone. Nestling at the entrance to the old tunnel heading west to Comrie lies the Ambulance Depot whilst due north of this is what was until recently Victor Marsh's Station Garage part of the original complex.

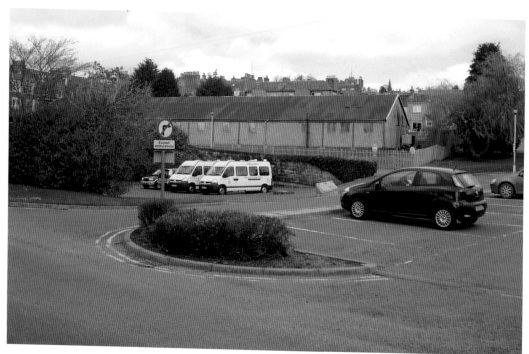

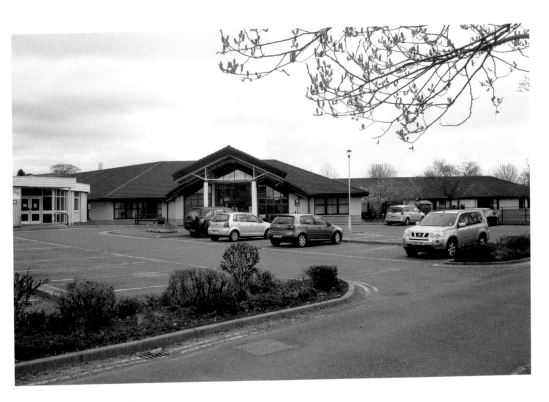

Cottage Hospital

Crieff Hospital (still referred to by most as the Cottage Hospital) relocated from Pittenzie Street some years back and provides an excellent service for the local people. It sits beside the original Health Centre now utilised by the NHS.

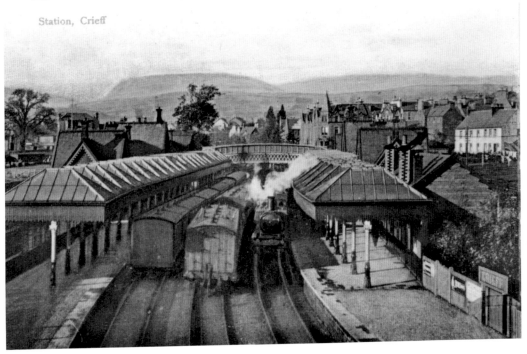

Station, Crieff

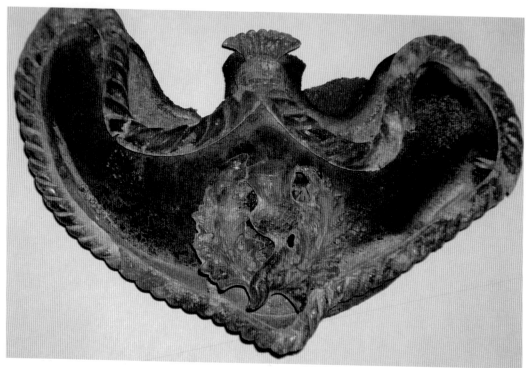

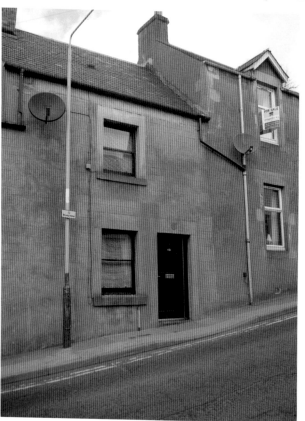

Hill Street Drovers Inn

This somewhat inconspicuous little terrace was for many years a drover's howff or inn. Renovated by the late John Robertson, Crieff builder, John found this incredibly well-preserved Highland sporran concealed in a recess. Identified as probably that of a drover chief, it is a unique reminder of the turbulent past of the town.

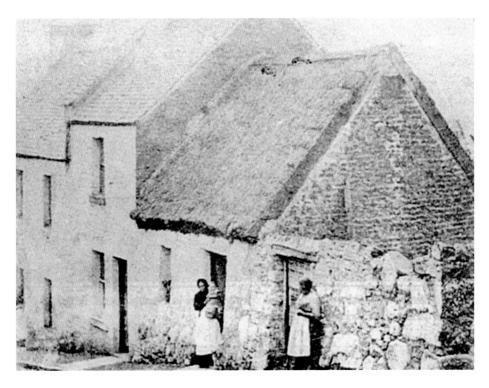

Hill Street Thatched House

The cottages or thatched biggins in Hill Street were some of the oldest properties in Crieff. This probably was the last one to survive. The lass with the bairn is directly related to well-known local residents Alec and Eric McCabe.

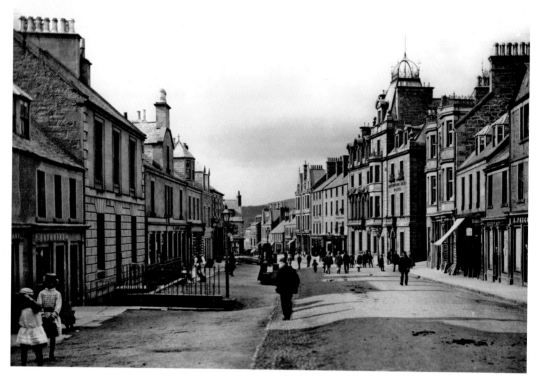

High Street

The view looking east towards the Drummond Arms Hotel clearly shows little change in the physical characteristics of most of the buildings. On the south side, the stairs running from street level to the basements have now all gone. The Drummond sadly has closed to trade and plans to turn it into flats have not yet materialised.

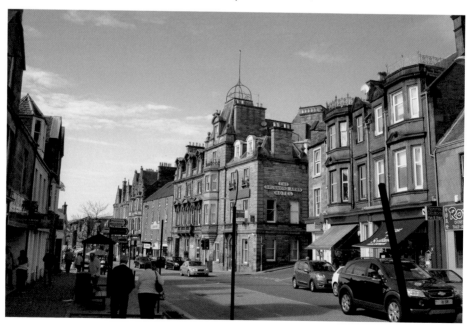

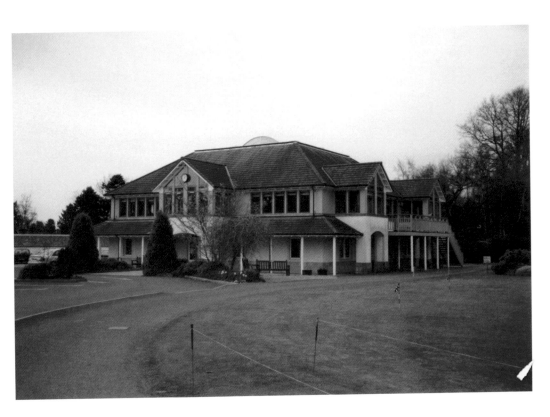

Crieff Golf Club
The handsome new clubhouse designed by local architects The James Denholm Partnership replaced this bungalow-style earlier version. The Club plays over the old Ferntower Estate gardens once home of the Preston family and General Sir David Baird, hero of Corunna whose monument set atop nearby Tom na Chaistel dominates the Strath.

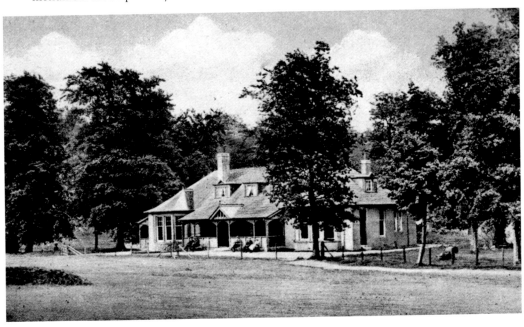

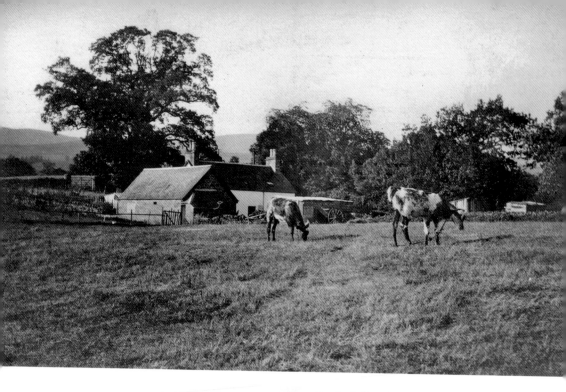

Eppie Callum's Tree

Located on one of the old droving routes into the town, tradition has it that Eppie Callum, mine host to a small hostelry planted an acorn in a teapot! The farm on the site has gone. More recently the Oakbank Inn plied trade but that building has now been converted into residential accommodation.

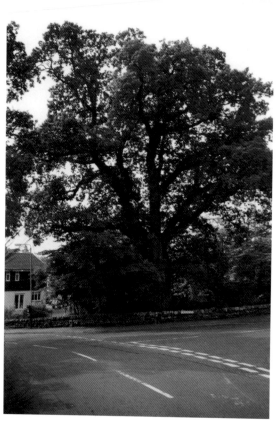

Crieff Cinema

This elegant building was constructed by local entrepreneur Peter Crerar in 1924 with some 650 seats. It lived on as a Bingo Hall before becoming an antiquarian bookshop to the front and flats to the rear in Church Street. Then it succumbed to the changing retail pattern of the small country town and now functions as a pub.

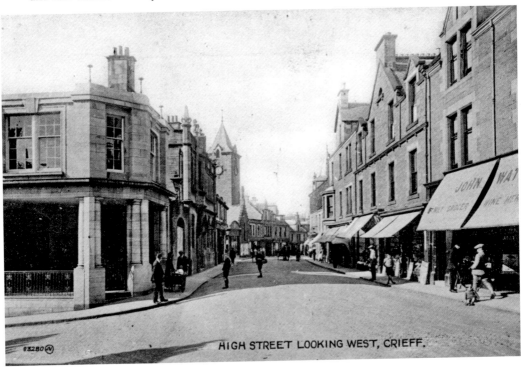

HIGH STREET LOOKING WEST, CRIEFF.

83280 (N)

25

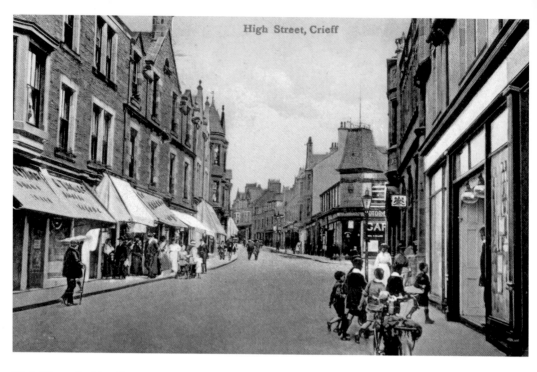

High Street looking East

Once again the passing years show little variance to the streetscape of High Street. The names of the shops have changed. The inevitable intrusion of the car now deters the pedestrian from venturing off the pavement!

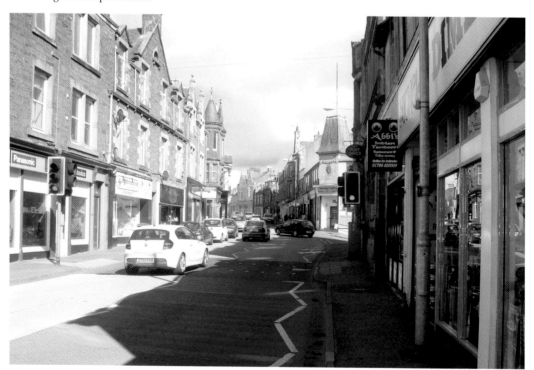

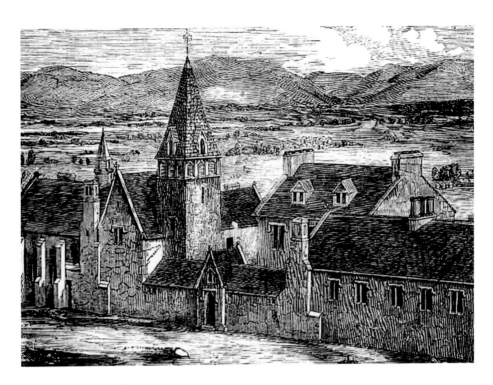

Crieff College Buildings

One of the most fascinating buildings in the town. Built as a college by Dr Malcolm from Madderty it became St Margaret's College for Young Ladies in the 1840s. The etching shows the enclosed courtyard of the time. A fatal outbreak of cholera saw the school close and the buildings went through a variety of uses from a police station with cells to weavers' houses. Now it is The Tower Hotel, flats and a private residence.

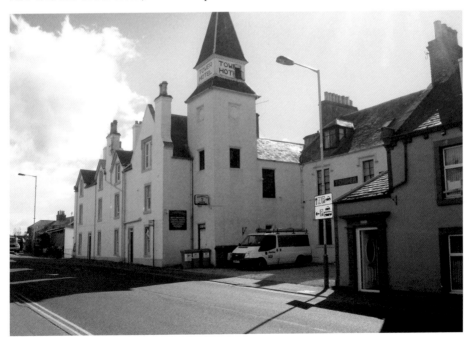

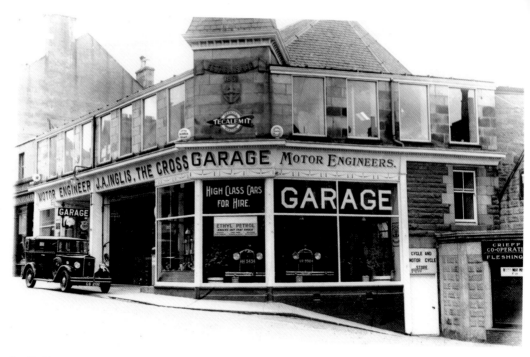

Inglis Garage East High Street

Located opposite the Cross of Crieff, the building was a stable (the hay lofts can still be seen to the rear) before becoming a garage in a much more casual environment. Converted into a drapery store by the local Co-op it eventually suffered yet another change when it was sub-divided into flats on the upper level and shops at street level.

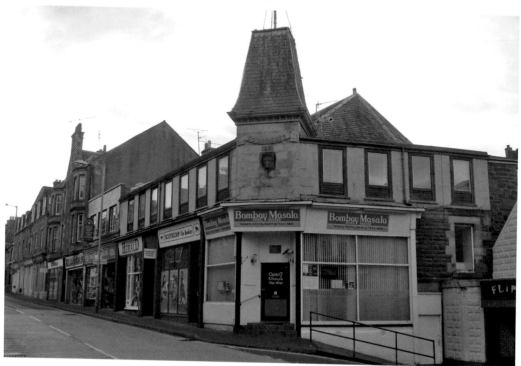

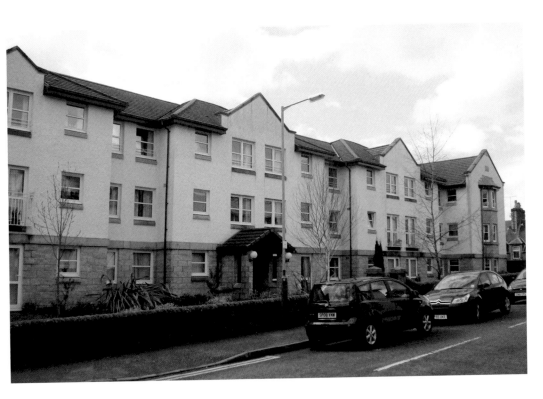

Old Cottage Hospital

The Victorian Cottage Hospital was pensioned off when the replacement was constructed adjacent to the then Health Centre at the old railway station. After a period these retirement flats arose on the site conveniently situated next to the Penny Lane shopping complex.

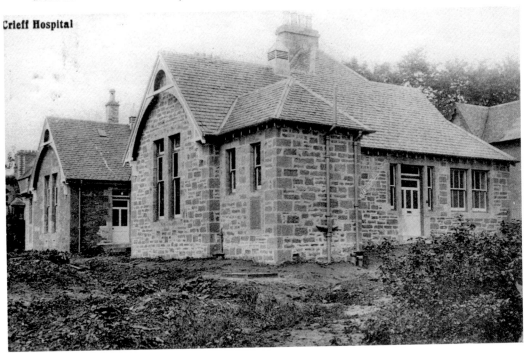

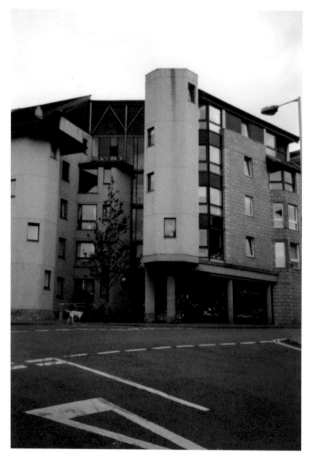

Scrimgeours Corner

This somewhat austere building traded as A. J. Scrimgeours Draper's for nearly a century. Located at the corner of West High Street and Comrie Street it was maliciously destroyed by fire. After lying vacant and becoming a real eyesore, it was developed for Servite Housing by architects Nicol Russell Studios and won a Saltire Award in 1993 and an RIBA Regional Award in 1994.

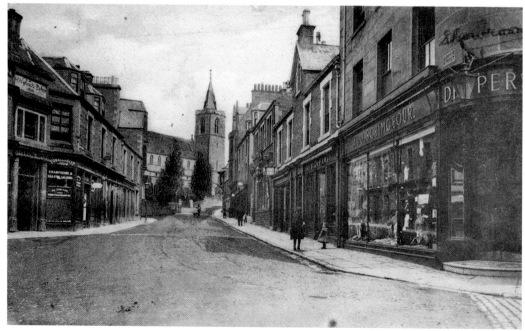

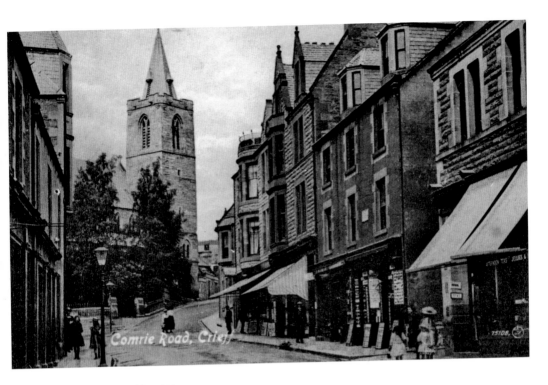

Comrie Street looking West

The trading pattern of the street has changed dramatically over the decades with the number of shops falling and an increase in the number of service units including dentists, lawyers and architects. The library closed in 2010 moving to the new campus in the south of the town.

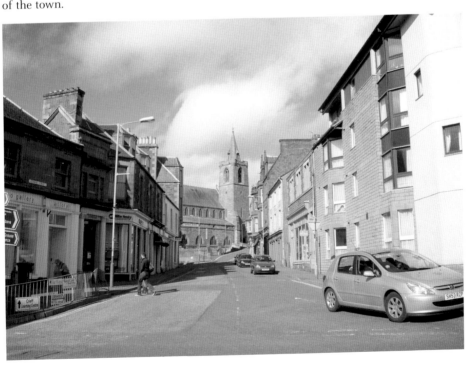

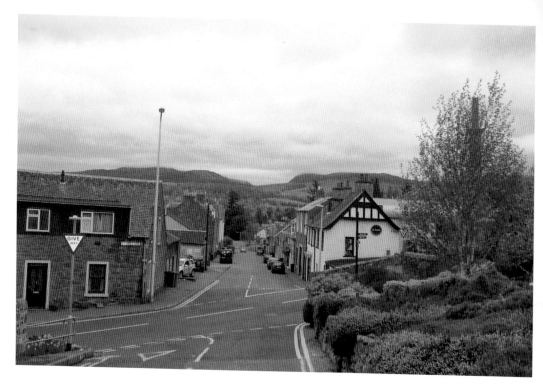

War Memorial

Located in a superb elevated location at the top of Burrell Street, the Memorial includes the names of not just those who gave their lives in the Two World Wars but also the Korean War of the 1950s. Whilst all the services are represented on the inscriptions, those from our local regiment The Black Watch dominate.

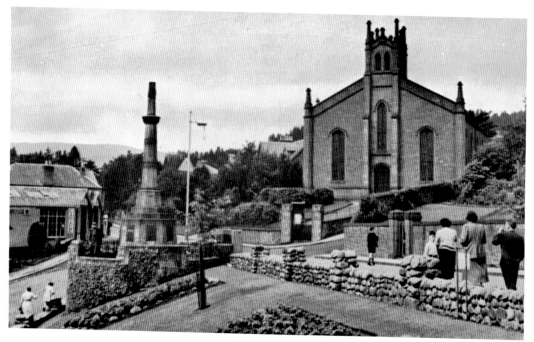

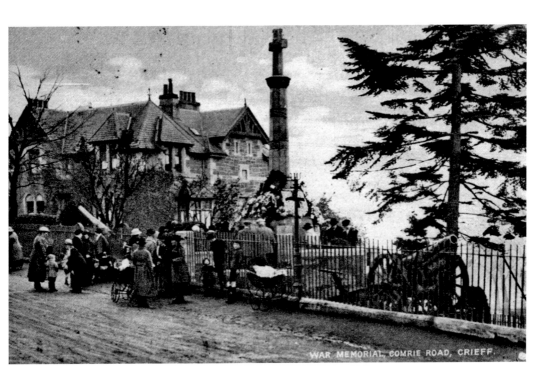

WAR MEMORIAL, COMRIE ROAD, CRIEFF.

War Memorial

The guns that were in position up until the start of the Second World War were, it is understood removed to a position in the south coast of England. Whether these Crimean veterans ever fired a shot is highly unlikely.

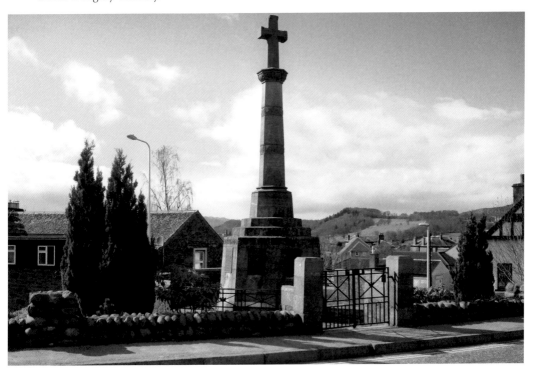

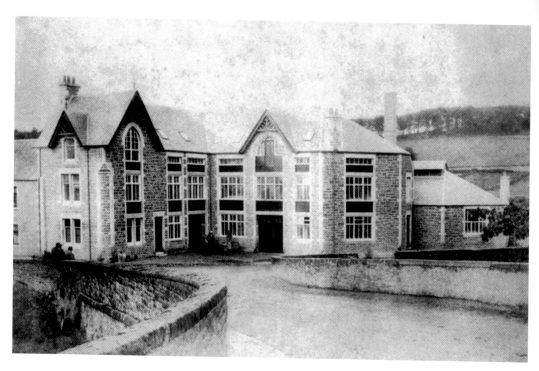

McNees Jammery

One hundred years separate these two pictures but they are remarkably similar. McNees manufactured jams and preserves from locally grown soft fruits. When they ceased trading after the Second World War, the buildings were used for the manufacture and repair of forestry vehicles by local businessman Alec McLarty. They were purchased by Hillcrest Housing Association as part of a significant development of affordable housing in the lower part of the town.

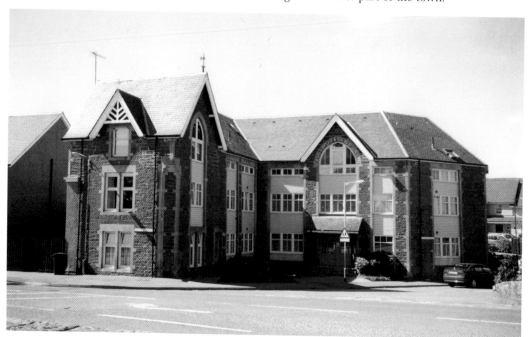

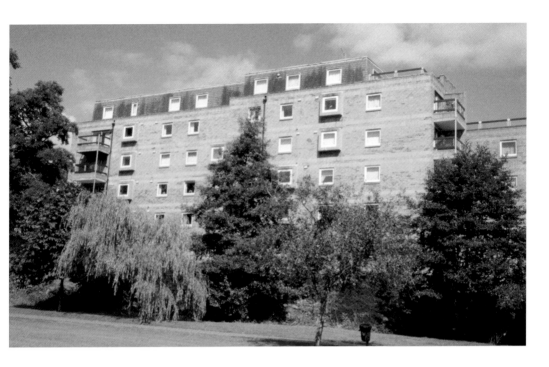

Milnab Mill

Meal mills were an essential part of rural Scottish life in the eighteenth and nineteenth centuries. They abounded around Crieff and other parts of Strathearn. The Milnab Mill (latterly known as Snodgrass's Mill) was demolished in the 1980s and replaced by Park Manor Residential Flats. This early picture depicts the bucolic bliss of yesteryear in the Strath – a time long since gone. The pastures shown in front of the mill have now been replaced by the well-manicured sward that is Taylor Park.

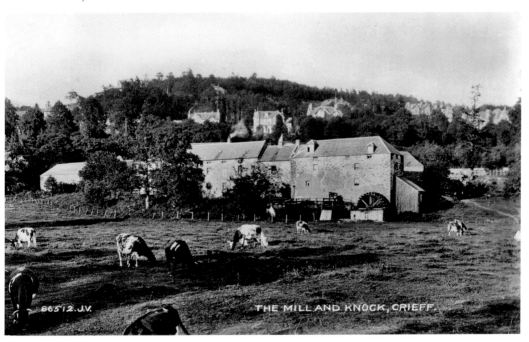

THE MILL AND KNOCK, CRIEFF.

86512.J.V.

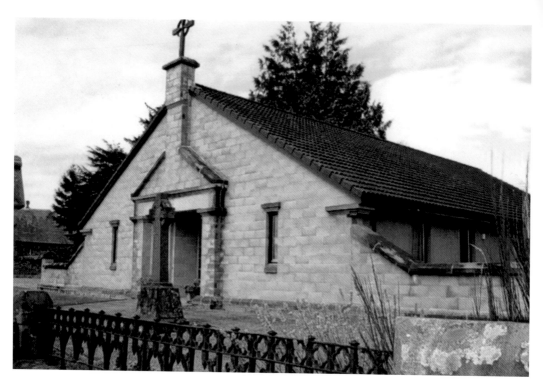

Episcopal Church

The original Episcopal Church stands in Lodge Brae (now a house and potter's gallery) before moving to the present location on the Perth Road. With a falling congregation and a building suffering from severe problems, it was demolished in the 1990s to be replaced by this somewhat more functional replacement.

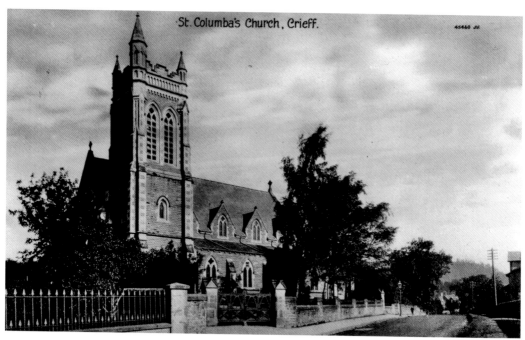

St. Columba's Church, Crieff.

45460 JV

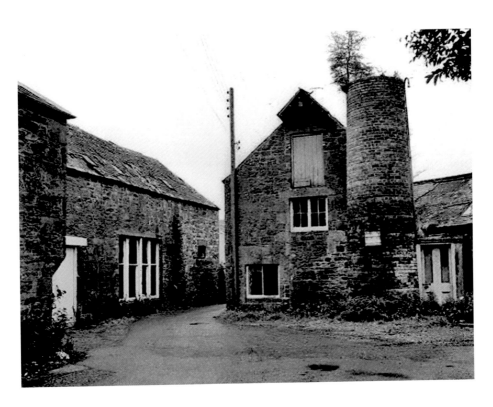

Dallerie Mills

The picture shows the mill as it lay semi derelict. McEwan's employed at one time over 200 workers. When it closed it became the Strathearn Laundry. The house was the family home of the McEwan family. The area around has become the playing fields for Morrisons' Academy and with a number of new houses having sprung up, Dallerie has regained much of its former buzz.

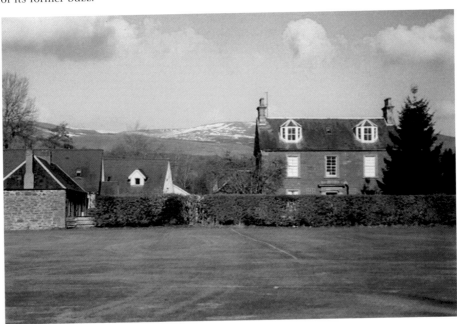

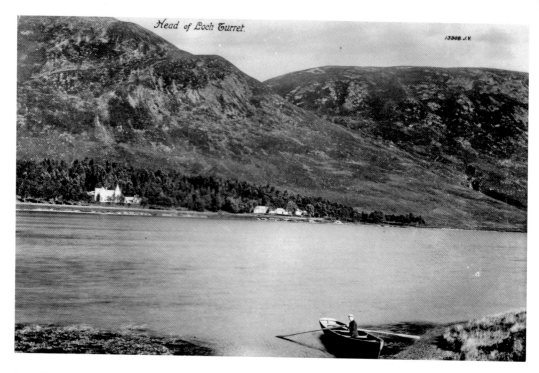

Head of Loch Turret.

Loch Turret

This was drastically changed by the building of the dam and the raising of the water level in the early 1960s. The boatman is beside Burn's rock where the poet wrote his ode the 'Water Foul of Loch Turret'. On the far shore is Rhuad Mhor, the shooting lodge of the Murrays demolished prior to the flooding.

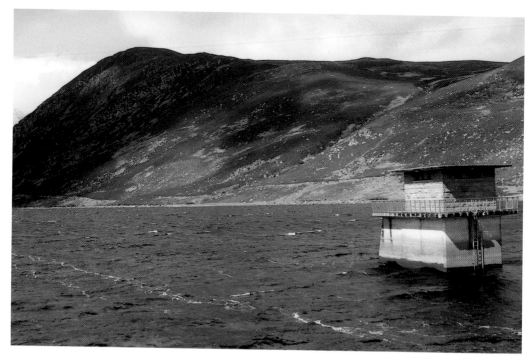

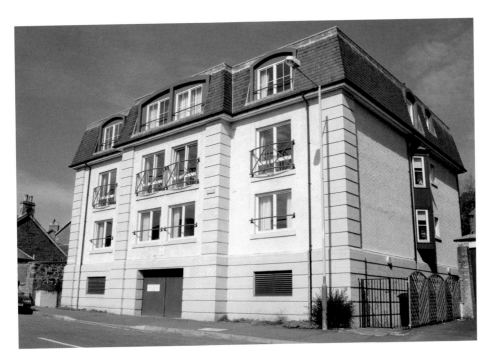

Cinema Meadow Motors Commissioner Street
This was the town's third cinema which again succumbed to the changing pattern of leisure in the town. It became a motor dealers and the lay empty for several years before it was demolished and replaced by this elegant apartment block. Congratulations to the architect who has replicated so many of the original details.

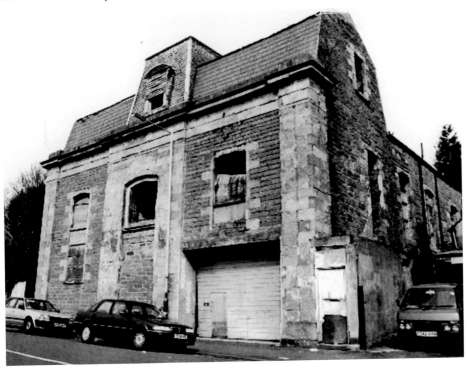

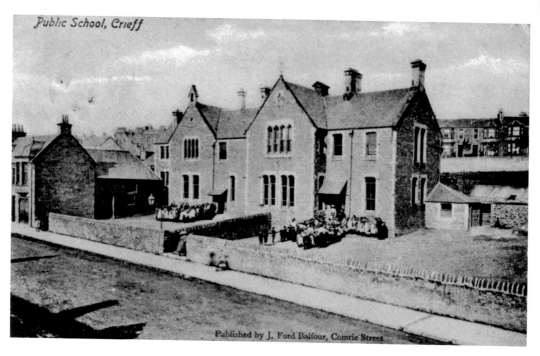

Published by J. Ford Balfour, Comrie Street

Crieff Primary School

The original school was located in the Parish Clerk's house beside the parish church in what is now Church Street. The Commissioner Street building was gradually added to over the years and became the Primary School when the High School opened in the 1960s.

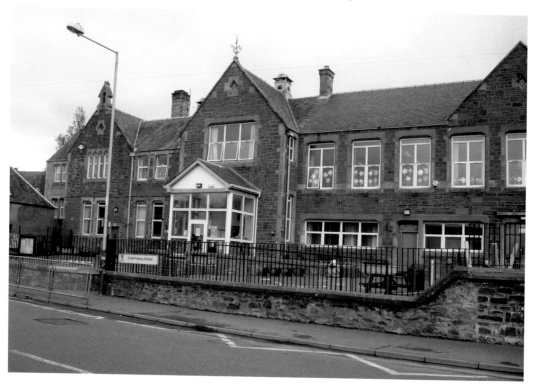

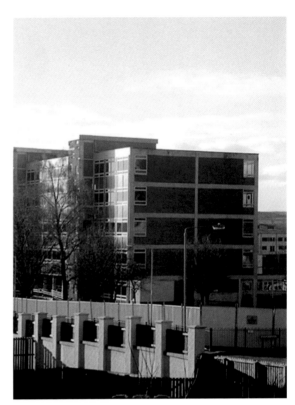

Crieff High School
A picture of the new High School
in the course of construction in the
1960s. A comparatively short life span
due to expansion saw it demolished
in 2010 when the new Strathearn
Campus was opened adjoining the
Recreation Centre.

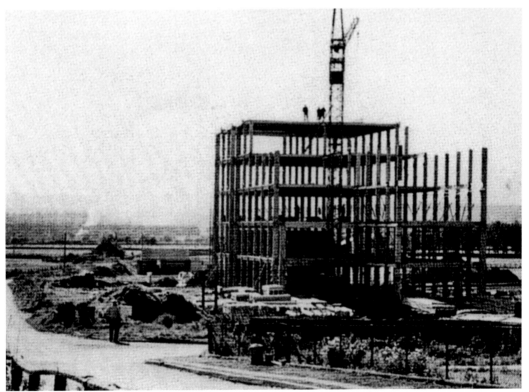

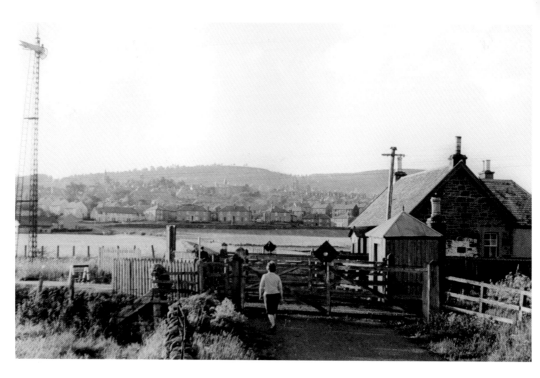

Robbie's Box

Robbie was the signalman at this busy crossing at Pittenzie Road. Now the home of David Campbell, well-known local bookseller and stationer, the outlook north to Leadenflower has changed dramatically since the demise of the railway. The new Strathearn Campus can be seen on the extreme left whilst the former Crieff High School, constructed after the older picture was taken, has been demolished and the land opposite has become a new housing development.

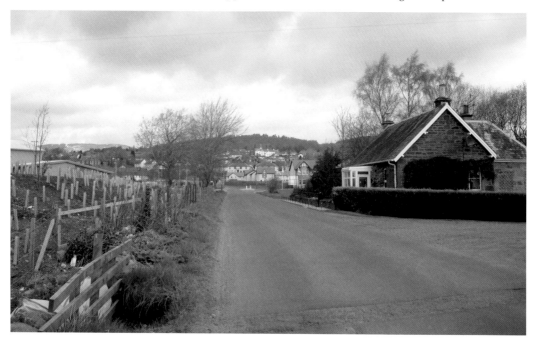

Published by J. Ford Balfour, Comrie St.

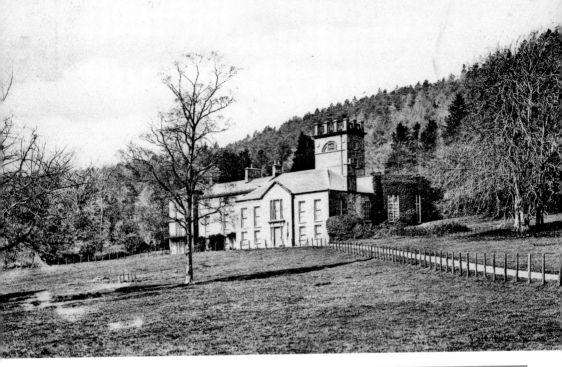

Ferntower

Not the largest of country houses, Ferntower was however an important part of the nineteenth-century Strathearn infrastructure. Queen Victoria nodded *en passant* to Lady Preston on her way to Abercairney. When sold in 1908 the sales brief was quite revealing. The Estate included some 3,300 acres and numerous farms and extended from as far west as the Lochlanes to as far east as Cargates in Madderty. Dr Meikle, the founder of the Hydro Hotel was resident in Ferntower at the time of sale and duly purchased the house and gardens. Sadly the house lay empty when the Burns family (of Burns Laird shipping) departed and was blown up in the 1960s by the Army as a planned exercise! The old stables complex was utilised for a while as Hydro staff accommodation but is now a crumbling ruin.

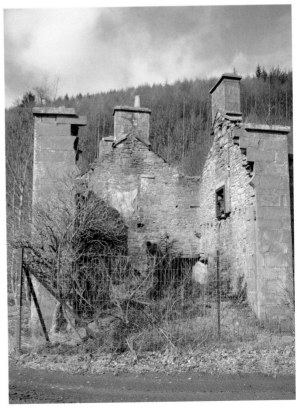

43

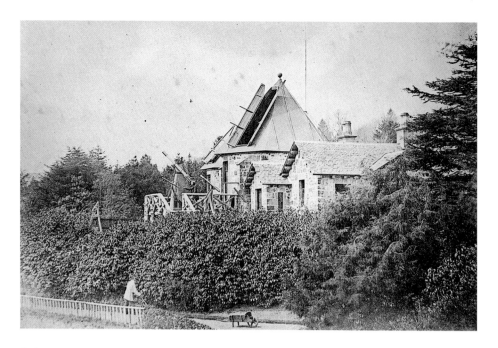

Ochtertyre

Sir William Keith Murray, Laird of Ochtertyre, was a kindly, benevolent man respected not only by the citizens of Crieff, but Scotland as a whole. Apart from being an accomplished singer Sir William was an astronomer of some note. He set up his observatory above what was a tennis court to the west of Ochtertyre House and purchased a 9" Cooke Refractor telescope (13' equatorial) with drive and smaller tripod mounted refractors. On his death in 1861 the equipment was gifted to the Hunterian Museum attached to Glasgow University. The observatory is now utilised as a garden bothy.

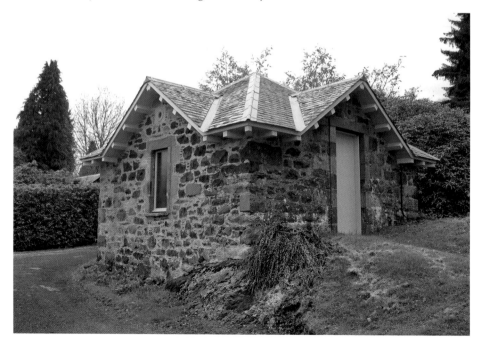

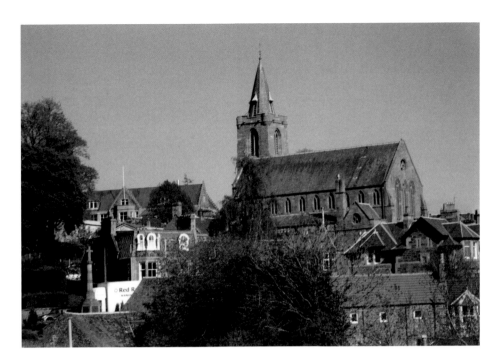

South Church

This unique picture taken in 1881 shows the final construction of perhaps Crieff's most elegant church building. Built as the Free Church of Scotland it became the South UP Church before finally returning to the Established Church fold. Much of the detail was culled from nearby Dunblane Cathedral. It finally succumbed to diminishing numbers, closed and was for a while an Antiques Warehouse. It now lies empty and in a declining state.

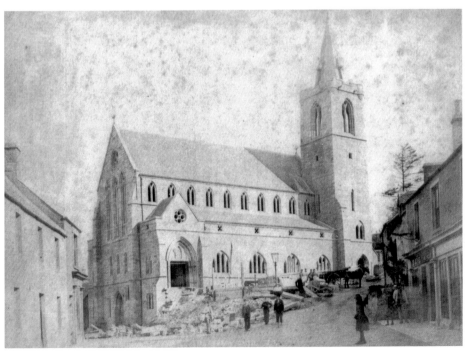

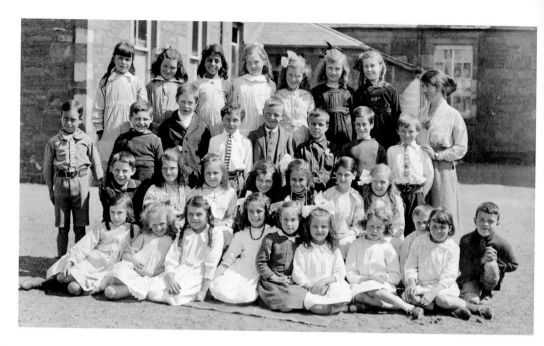

Taylor's Institute

Taylor's Institute was established in 1842 by William Taylor of Cornton, a local merchant to educate the poor of the town. It established a fine reputation and was eventually absorbed into the local Primary School. The building is now the British Legion Club. This picture shows the teacher in the playground with her hand on the shoulder of Tom Cuthbert Dewar. Tom was in the RAF and was killed in the Second World War. He is buried in Holland and his name is on the local war memorial. His family were Dewars the Plumber's in East High Street.

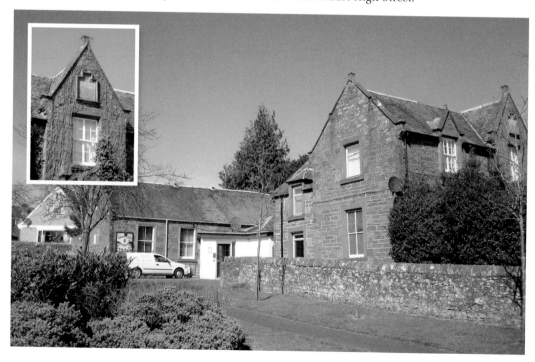

King Street Lower

This part of King Street was one of the busy parts of Crieff when the railway station was located here. The construction of the Somerfield supermarket, the Health Centre and the Hospital have brought the bustle back to this end of the town.

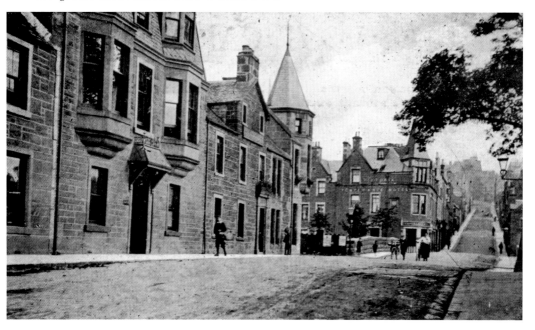

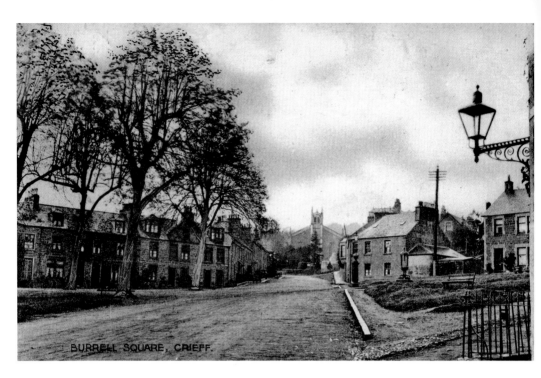

BURRELL SQUARE, CRIEFF.

Crieff Burrell Square

Once known as the Octagon, the terrace shown on the left of the pictures was built in the 1820s and many of the houses still retain the attractive features of yesteryear. The more recent cherry trees and flower beds on the eastern side of the Square provide an attractive welcome for those heading to the centre of the town.

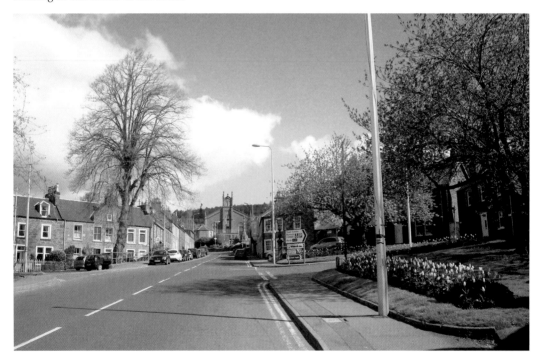

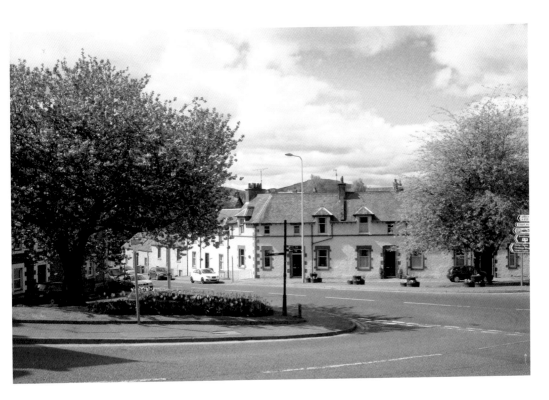

Crieff Burrell Square

Looking south-west across the Square, we see the later Victorian terraces. The well-tended flowerbeds and strikingly beautiful flowering cherry trees have added greatly to what is undoubtedly one of the real gems of Crieff. Still in place but dysfunctional are the attractive nineteenth-century lamp standards with their ashlar piers with panelled sides, somewhat more appealing than the ugly modern street furniture than adds nothing to the charm of the past.

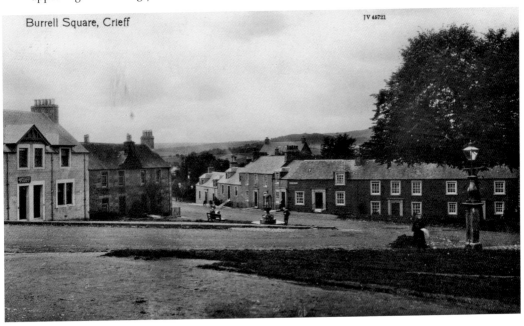

Burrell Square, Crieff

JV 45721

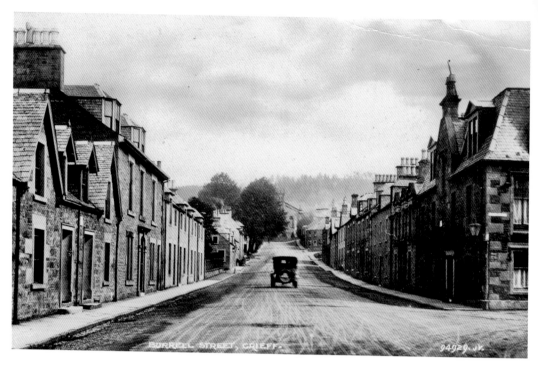

Burrell Street

The Commissioners of the Forfeited Estates feued or sold plots of ground in Burrell Street to self-employed linen handloom weavers after the '45. Traces of their presence are shown in the projecting loom sheds to the rear of the properties.

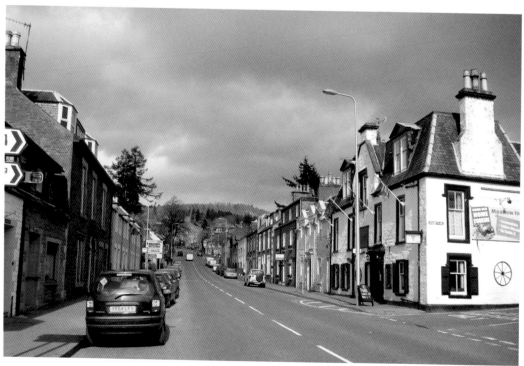

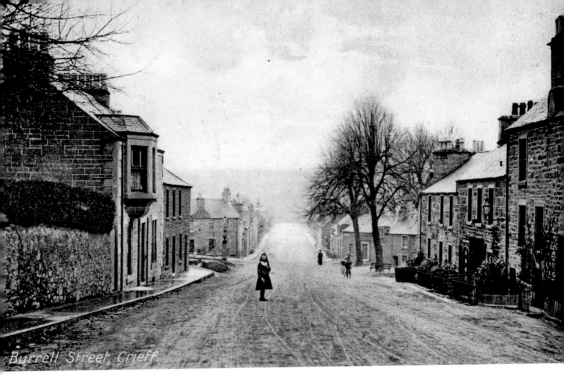

Burrell Street, Crieff.

Crieff Burrell Street looking South
The main road heading south to Stirling, many of the houses are early nineteenth century with extensive gardens to the rear. Named after one of the branches of the Drummond/Willoughby de Eresby family the feudal superiors of this part of Crieff. The young lady shown in the picture is Miss Fraser who lived for many years with her sister in Burrell Square.

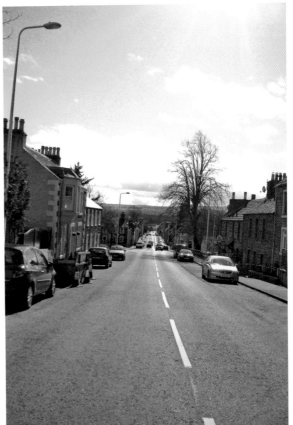

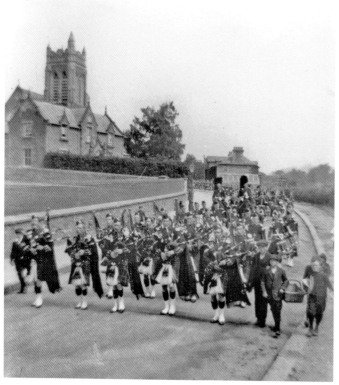

Lauder Park

A feature of summer in Crieff was the frequent army parades. Regiments held camps in places like Monzie and marched to and from the railway station. This large parade passing Lauder Park is probably the local Black Watch and dates from about 1920. The changes apart from the trees are that the tower of the Episcopal Church rising behind the Taylor Institute was demolished *c.* 1995 and the vacant ground to the right after an existence as a filling station is now the House Proud store.

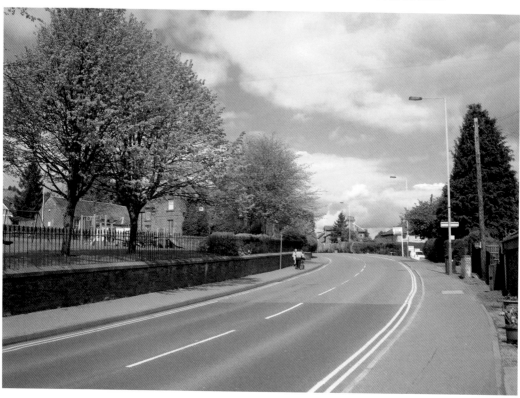

COMRIE, ST FILLANS & LOCHEARNHEAD

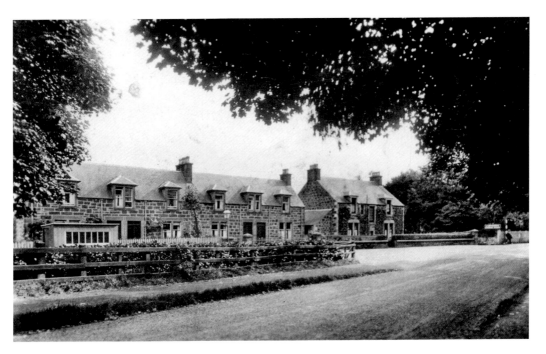

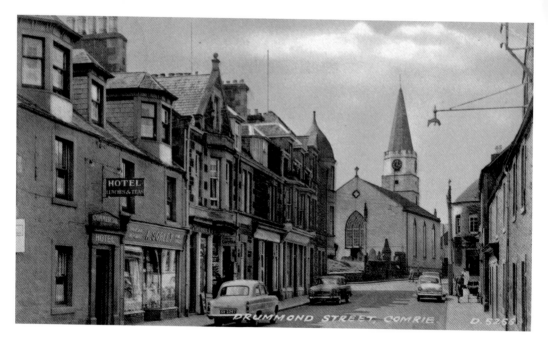

Drummond Street

Drummond Street is the main road of the village. Its mid nineteenth century architecture is distinctive and varied adding much character to the approach from the east. The White Church dominates the scene. No longer used for worship, the former parish church is now well utilised as a community centre.

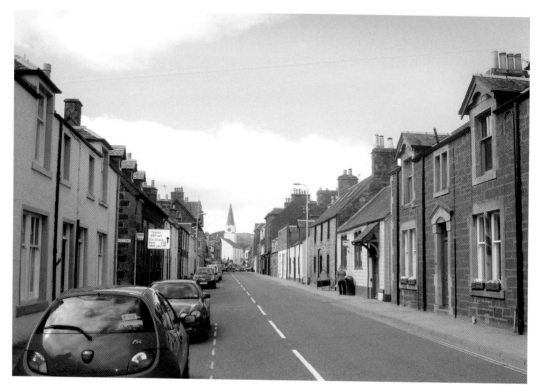

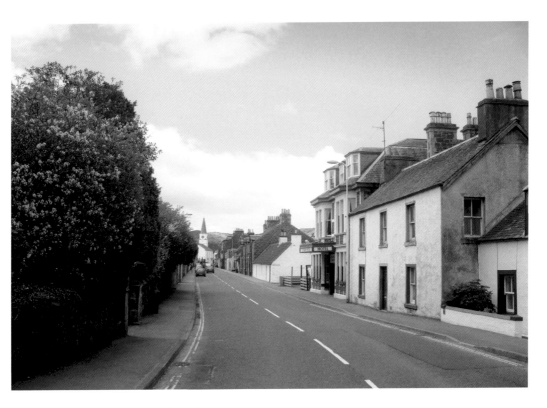

Drummond Street Comrie looking West
The sixty plus years that separate these photographs show little change apart from the introduction of the ever intrusive yellow lines! The Comrie Hotel still functions as before but the Ancaster Arms further up the street has had a partial conversion to residential use.

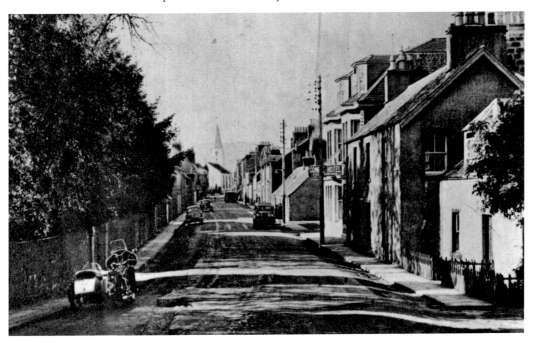

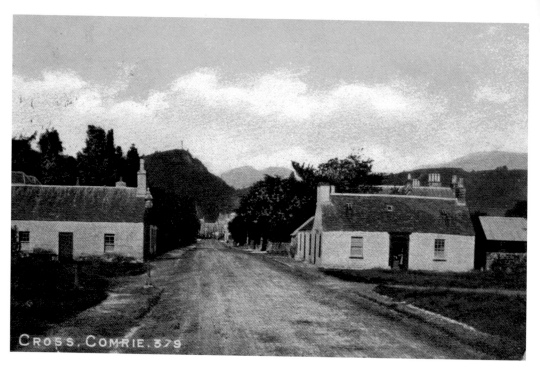

Comrie Dalginross Cross Roads

These weavers' cottages dating back to the late eighteenth century were typical of the 'village' of Dalginross separated by the Earn from Comrie. The one on the left has had an upper floor added to turn it into a more substantial family home.

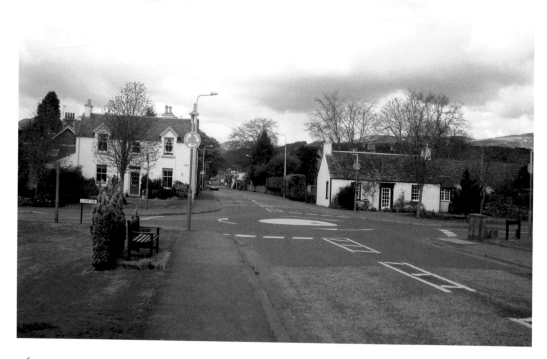

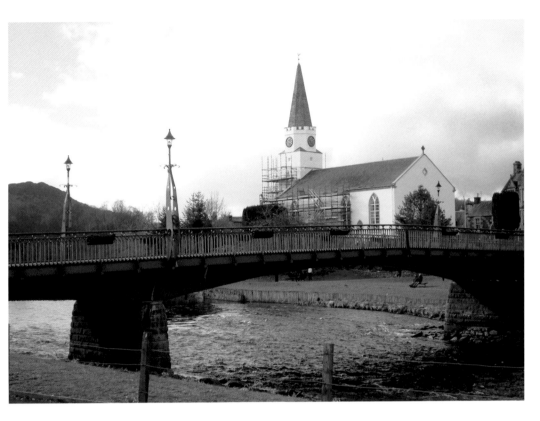

Comrie Dalginross Bridge
Despite the loss of the riverside footpaths on the south bank of the Earn to the inevitable new housing, Comrie has managed to maintain its rural ambience by the new pathways and grassed areas running along and below the White Church.

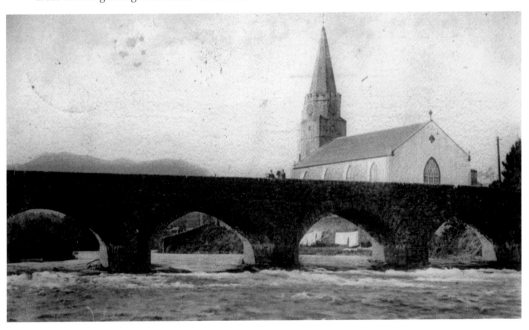

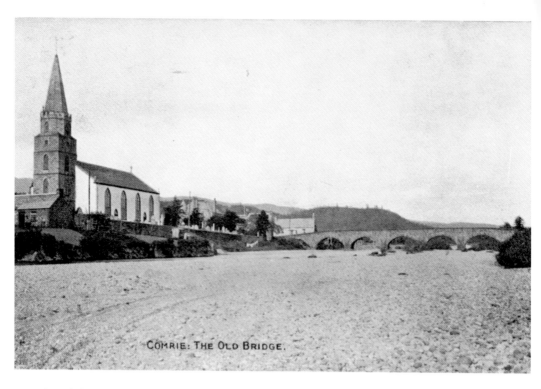

COMRIE: THE OLD BRIDGE.

Comrie Dalginross Bridge and White Church

The old Dalginross crossing was replaced in 1904-05 by this elegant three span steel girder bridge designed by the renowned Glasgow based Sir William Arrol & Co. The White Church (originally the Parish Church) now functions as an active community centre.

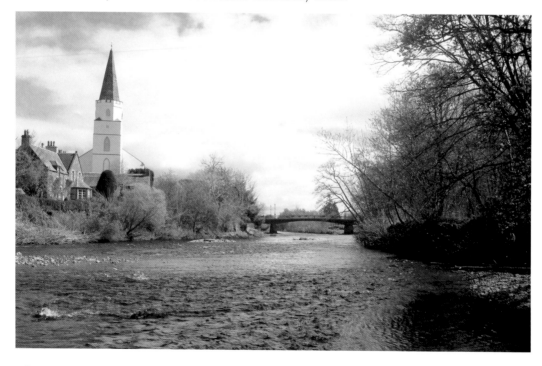

Ross Bridge

Although now well over 200 years old, the Ross Bridge is something of a gateway to the past. The area known as the Ross was very much a community with a specific identity. The Gaelic-speaking residents of the Ross in the eighteenth and nineteenth century were for the most part self-employed handloom weavers and many of the distinctive little cottages that remain were occupied by these skilled artisans of yesteryear. The name itself means in Gaelic an isthmus or a peninsula as indeed you readily find out as you follow the tortuous narrow road that meanders into the hinterland of this unique part of Strathearn.

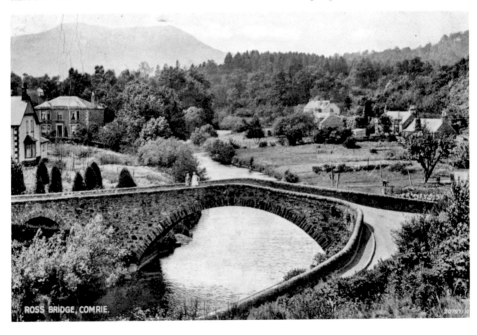

ROSS BRIDGE, COMRIE.

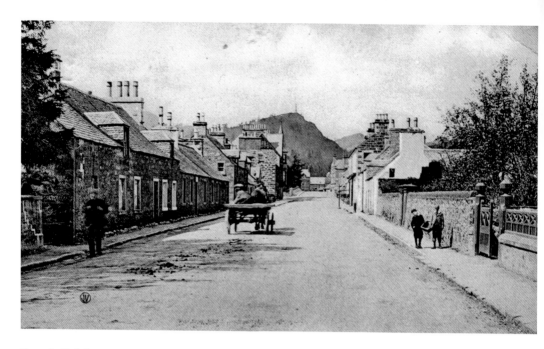

Comrie Dalginross

An analysis of the occupational and residential statistics of the village over the last century and half shows an incredible seachange from a Gaelic-speaking community where handloom weaving dominated to a retirement oasis in the heart of Perthshire. Dalginross with numerous older style cottages dating back to the late eighteenth century reflects much of the village's working past.

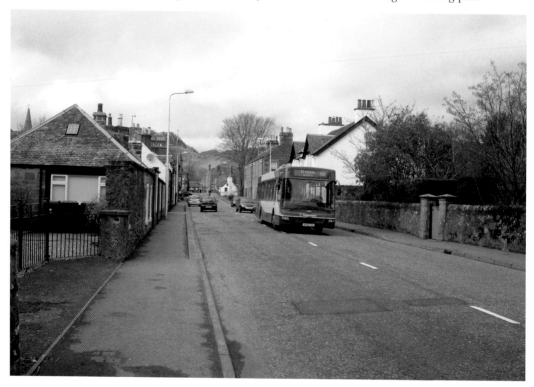

Comrie Dundas Street
The two-storey traditional terraced houses making up most of the streetscape of Dundas Street are mostly nineteenth century and yet again have altered little visually over the years.

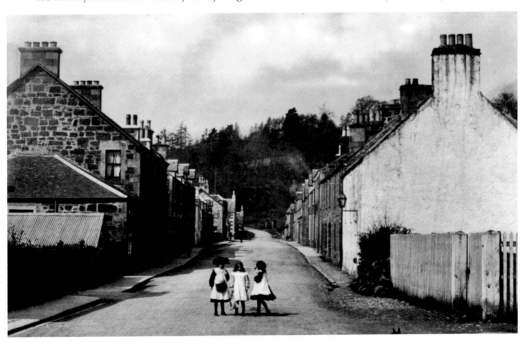

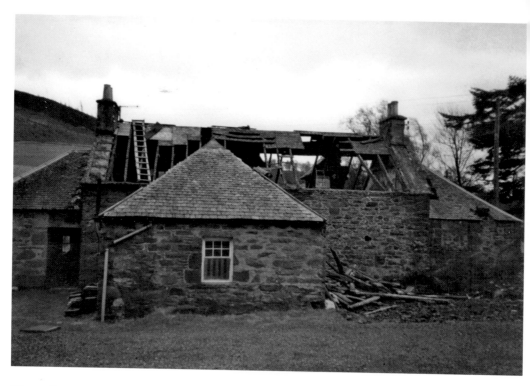

Glentarf

Located in the hills above Comrie, Glentarf was an old fermetoun or clachan supporting a number of families on the land. The buildings fell into disrepair until Alan and Vida Rose purchased them in the early 1990s transforming them into this delightful country home.

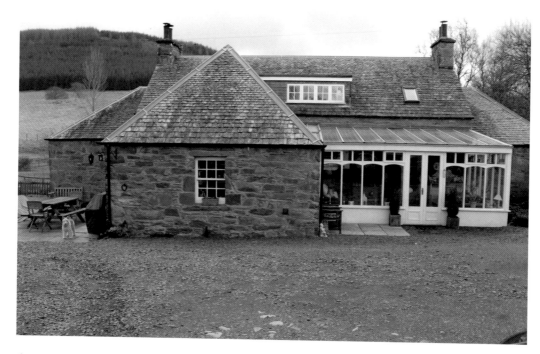

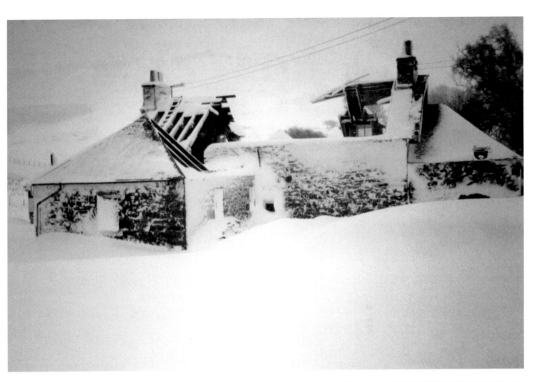

Glentarf Seasons
The beauty of this quiet part of upper Strathearn is personified by the contrast in the seasons. The winter of 1993 was not conducive to the rebuilding task. Some seventeen or so years later that is but a memory and the garden now benefits from Alan's bees.

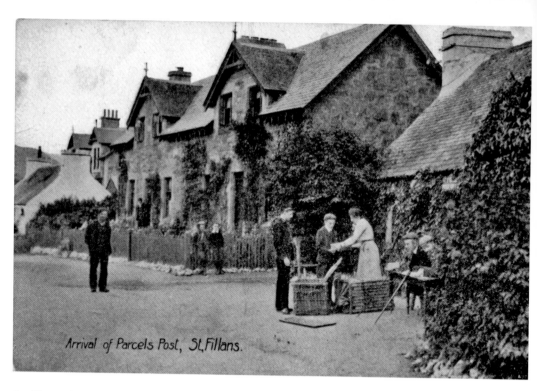

Arrival of Parcels Post, St.Fillans.

St Fillans, the Old Post Office

Because the railway did not reach St Fillans until 1901 the village would have been quite isolated. The railway company ran coaches to Lochearnhead periodically and the arrival of the parcel post shown above would have been an undoubted occasion in the pre motor car era. The post office is now an attractive cottage with an upper floor added.

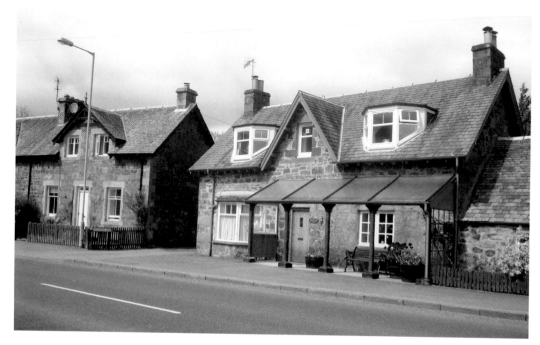

Lochearnhead Hotel

The impressive Lochearnhead Hotel owned by the renowned local Highland Games athlete Ewan Cameron was destroyed by fire in the early 1970s. After lying derelict for many years badly needed new housing has now arisen in its place.

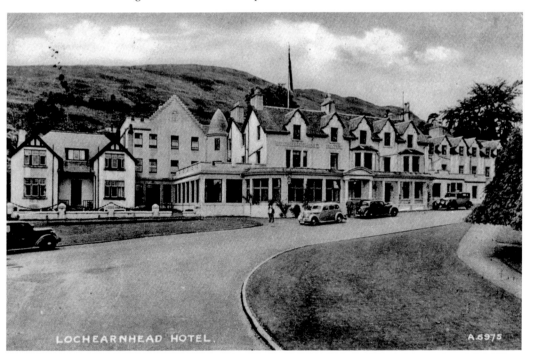

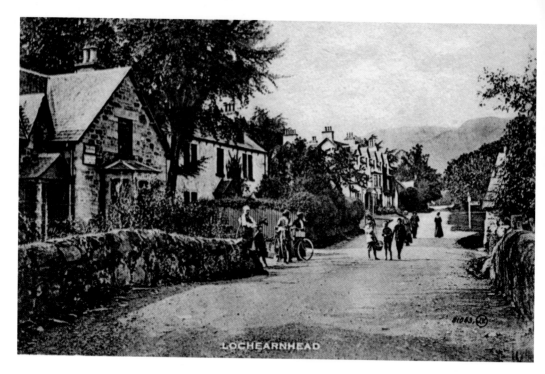

Lochearnhead Street

Lochearnhead in the 1920s was a tranquil yet busy little village well served by rail links from Perth and Stirling. After the station opened in 1904, this part of Perthshire was opened up to the tourist.

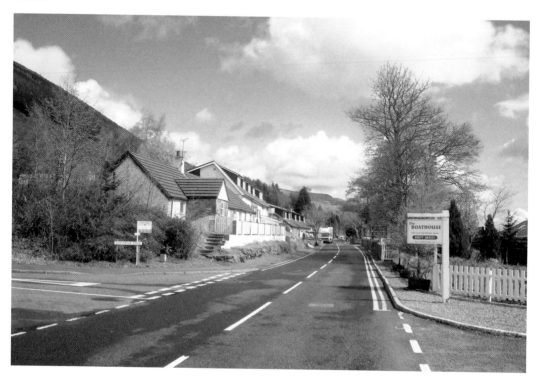

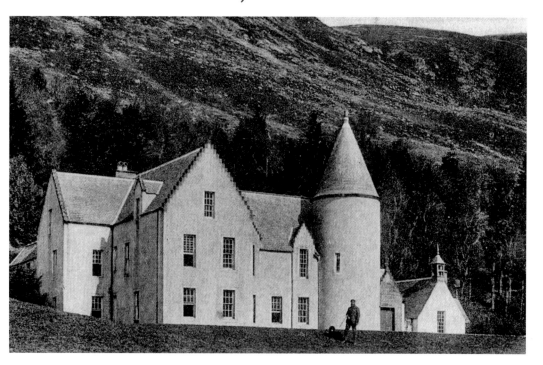

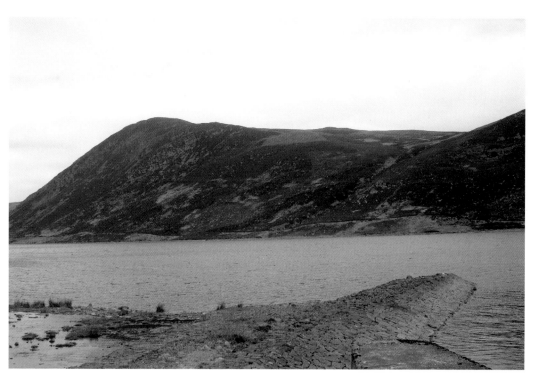

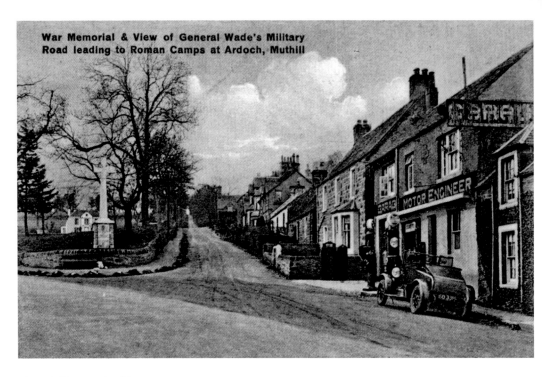

War Memorial & View of General Wade's Military Road leading to Roman Camps at Ardoch, Muthill

Thornhill Street looking Up

Thornhill Street was the line of General Wade's military road constructed after the earlier of the Jacobite uprisings. In all probability he followed the line of a much older Roman road from Ardoch camp leading northwards to the 'glen blocker' at Fendoch in the Sma' Glen.

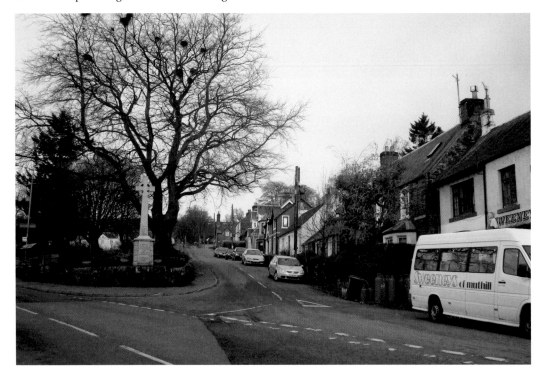

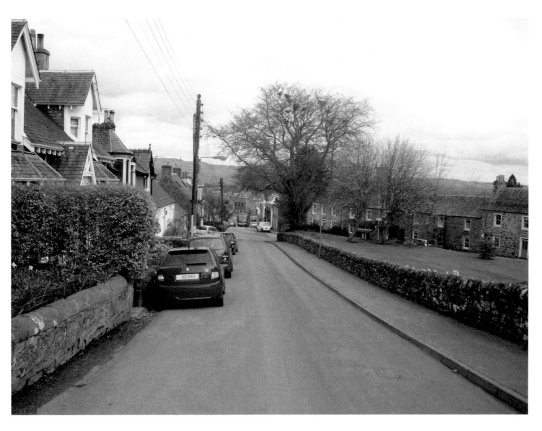

Thornhill Street looking North
Highland Park on the east side of Thornhill Street was a stopping off place for the drovers on their way to the Falkirk Tryst in the late eighteenth century and from the Crieff Tryst in an earlier period.

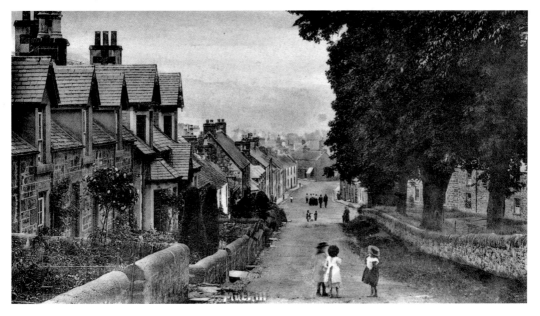

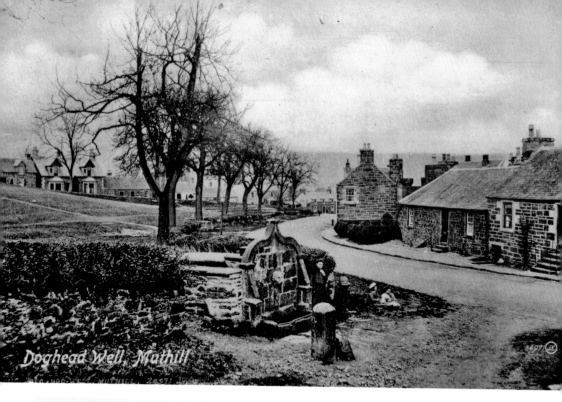

Doghead Well, Muthill

Dog's Head Well Highlandman's Park Muthill

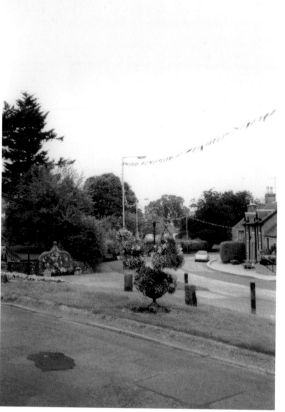

Not much has changed in the hundred plus years spanning these two pictures. Taken at the junction of Willoughby and Pitkellony Streets to the south of Highlandman's Park you can see that the smaller of the two cottages has gone to be replaced by a two-storey 'semi'. The upright posts are the original drovers' hitching posts and look like something out of a cowboy movie! Here the Highlanders paused on their way to the Falkirk Tryst for a drink of the pure cool burn water that flowed through the park. Sadly the cup attached to the well in the early picture has long since gone and the raising of the ground level over the years has seen the demise of the stone trough and the burying of much of the first post.

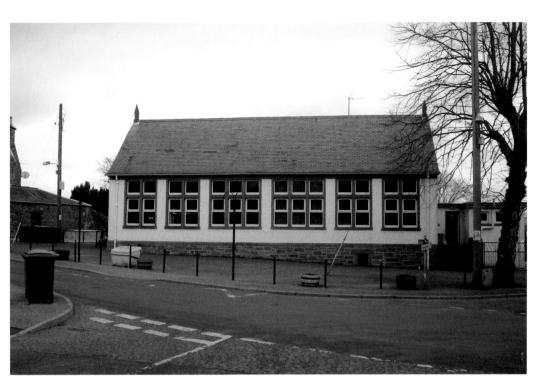

Muthill Public School

The school was added to in 1934 to provide much needed additional accommodation. Necessity has lost much of the charm of the original. Rural schools are a vital part in the infrastructure of small communities such as Muthill.

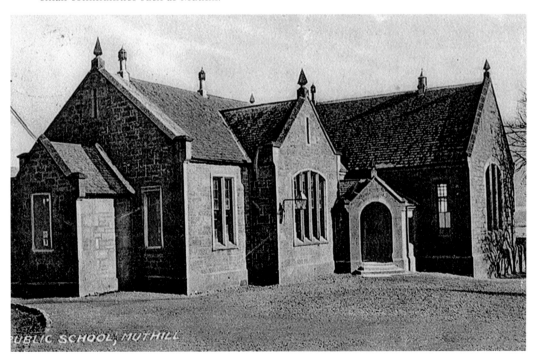

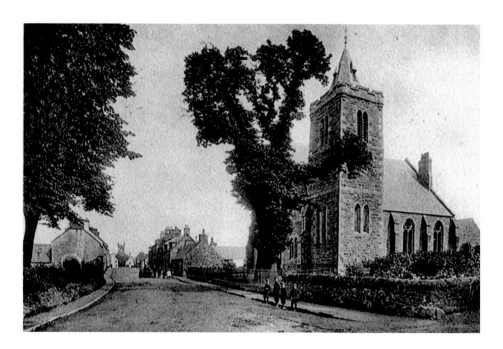

Muthill Free Church

Strathearn was strongly religious place over the years. In the eighteenth century the Established Church of Scotland was rocked when the 'marrow controversy' erupted in nearby Auchterarder when an outspoken number of clergy seceded from the Kirk on a matter of doctrine. A century later a further disruption saw the creation of the Presbyterian Free Church of Scotland. Numbers of the new breakaway church outnumbered that of their established brethren. This imposing edifice was erected at the end of Drummond. Note the clear view of the tower of the Parish Church at the end of Drummond Street – a sure reminder to the congregation each Sunday! The passage of time saw the healing of old wounds and the two were eventually reconciled. The Free Kirk became the church hall for the Parish Church and was eventually demolished in the 1980s. The vacant site was purchased by Paul Teale and a small workshop and house now occupy the site.

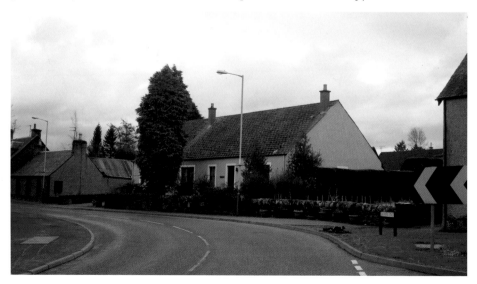

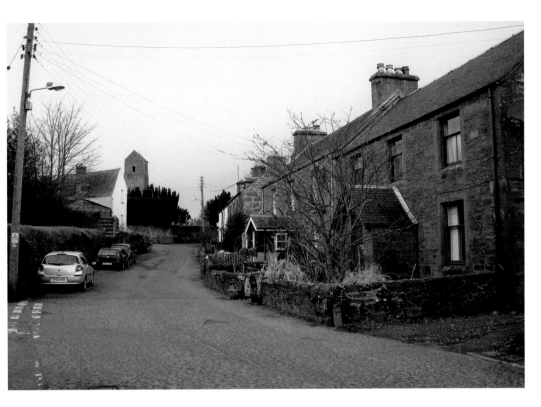

Wardside Muthill
This early nineteenth-century terrace typifies much that makes the village unique locally. Prosperity from handloom weaving was a key factor in the rebuilding carried out in the eighteenth and nineteenth centuries.

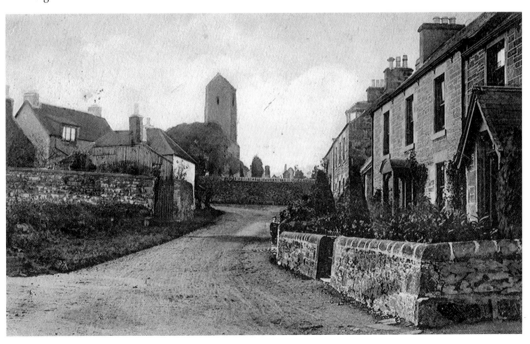

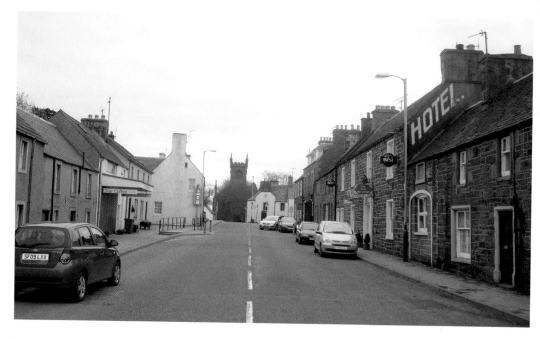

Drummond Street Muthill, looking East

Named after the Drummond family the Earls of Perth, it is dominated by the imposing structure of the parish kirk looking eastwards. Many of the buildings are unchanged in external appearance. The archway and passage of the building on the right have been turned into additional accommodation. The concerted efforts of the people in the village have transformed the summer appearance with hanging baskets and floral displays adding a delightful touch to this most historic of villages.

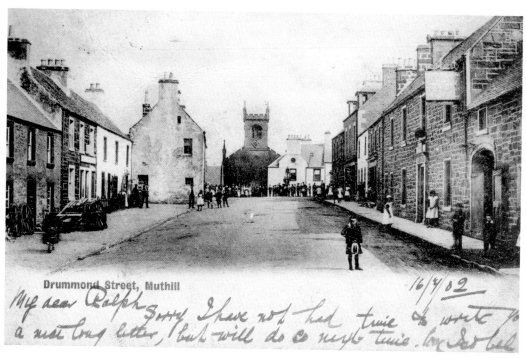

Drummond Street, Muthill

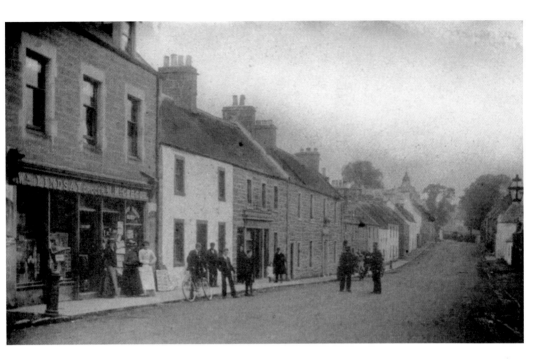

Drummond Street Muthill, looking West

Muthill was one of the Strathearn villages burned as part of Marr's 'scorched earth' in the aftermath of the 1714 Uprising. Drummond Street contains some of the oldest houses. Rebuilt in an individualistic manner we are fortunate that starting with the formation of a Civic Trust in the 1970s there has been a continuing local spirit and positive attitude to the preservation of Muthill's unique past. A sundial dating back to 1748 can be seen at No. 48.

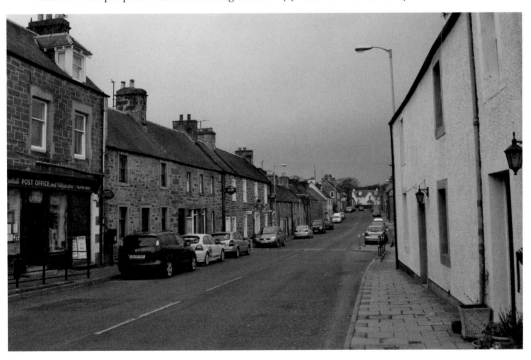

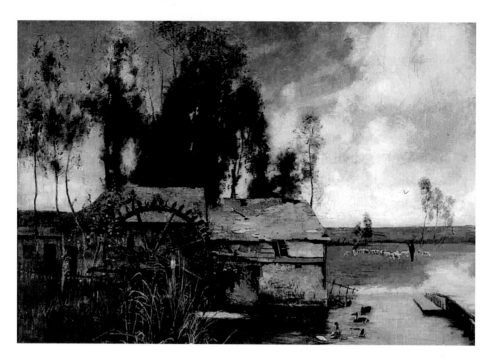

Strageath and Dornock Mills

These two meal mills were located directly opposite one another on a singularly spectacular stretch of the Earn. Strageath was the site of a first century Roman 'marching camp' built by Gaius Julius Agricola in AD80. In pre Reformation times, Strageath was an important religious centre. The mill itself has according to local worthy McAinsh Brown have not been in use for over half a century. The original mill lade and channel have been filled in but, as can be seen, much of the original fabric of the old mill still remains. The picture of the mill was painted in 1887 by Catherine Wright RSW and was kindly donated by a Canadian descendant to the ancient Library of Innerpeffray, located just across the river from the mill.

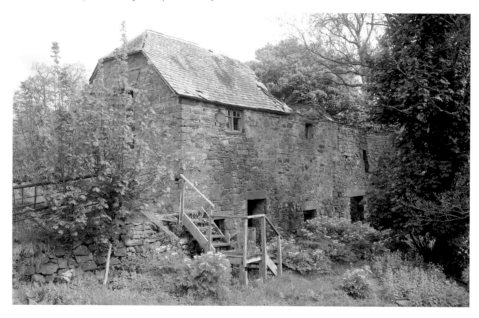

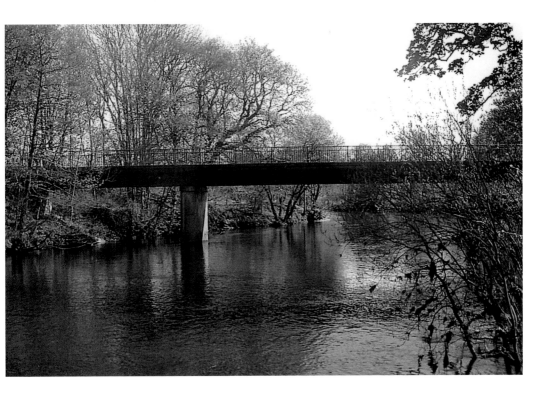

Strowan Bridge

The old bridge became structurally unsound and the new bridge was built downstream and the road realigned. The old church and graveyard of Strowan which is pre Reformation was isolated but still can be visited. Strowan was the central point of the old parish where the ancient Pictish cross now in Crieff was located.

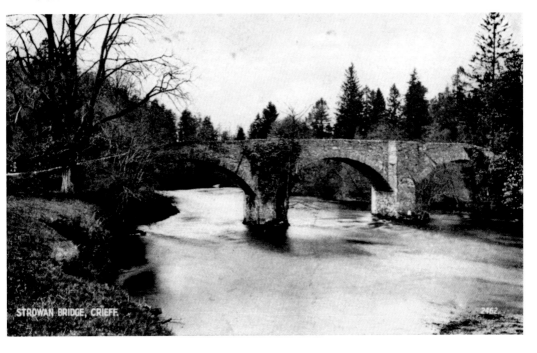

STROWAN BRIDGE, CRIEFF.

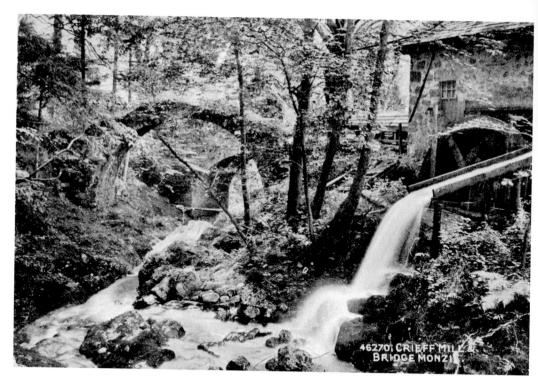

Monzie Roman Bridge

Erroneously termed 'Roman', this is one of the many examples in the area of a pack bridge which gave access to the travelling pack man and his horses to bring his wares to the people of the village. The mill is gone but the spot near Monzie Kirk still retains a peaceful charm.

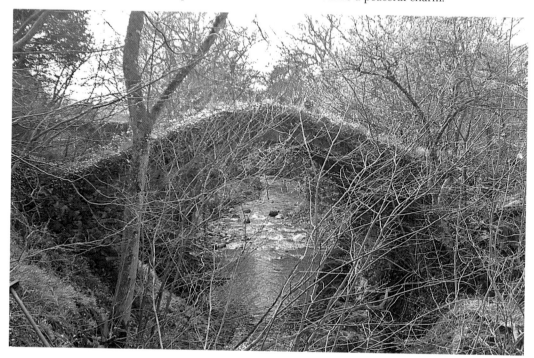

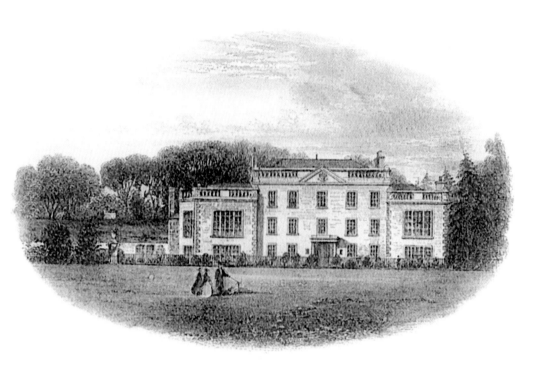

Inchbrakie

Once the home of the Graeme family, this delightful country house complete with some 365 acres of land and gardens was sold in 1878 and subsequently demolished. All that remains now is this little mausoleum built from the salvaged masonry of the house to remind us of its past greatness.

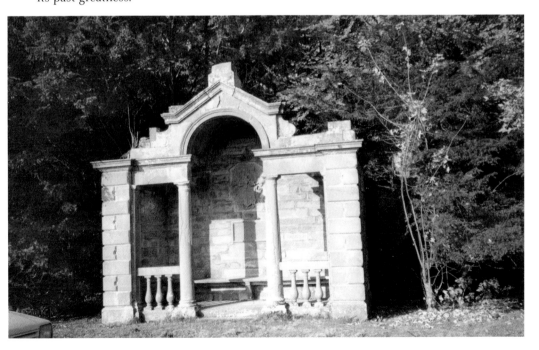

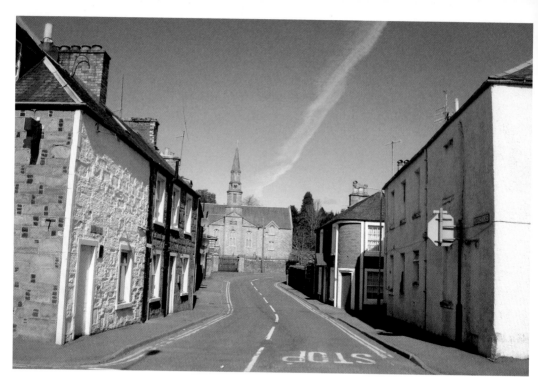

Methven Church Street

The old Parish Church which dominates the street is on the site of an earlier pre Reformation structure. The three shops in the older picture have long since gone having been transformed into housing for the village's expanding population.

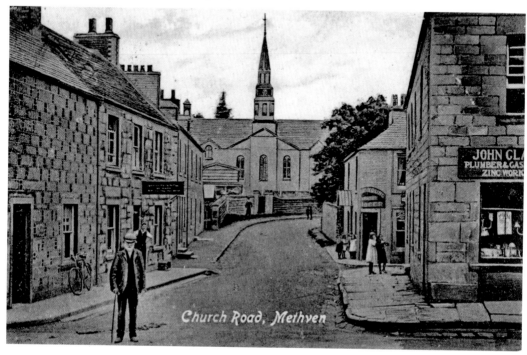

Church Road, Methven

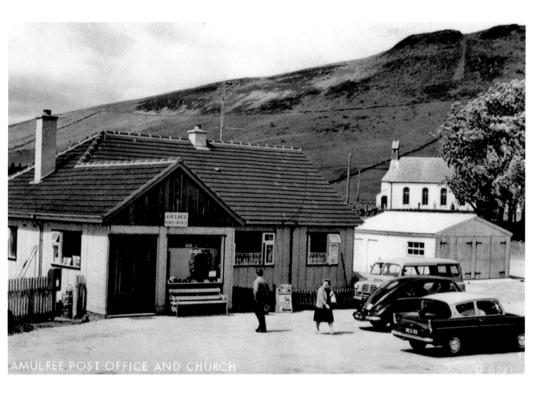

AMULREE POST OFFICE AND CHURCH

Amulree Post Office

A popular little shop, tearoom and post office which sadly has ceased to function as such, and has reverted to a private residence. It was, when in existence, the only retail outlet for a radius of about ten miles.

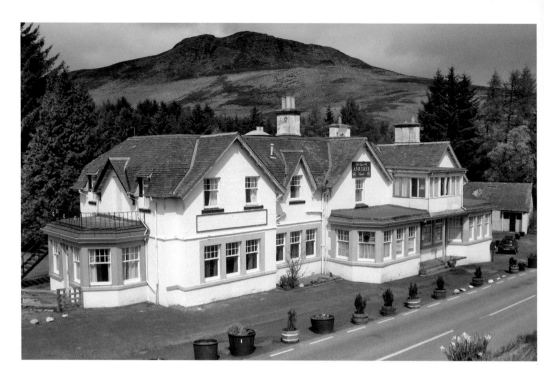

Amulree Hotel

This old drovers' inn dates back to 1714 and is reputed to have been used by General Wade when he was building the military road through the Sma' Glen. It was popular with the citizens of Crieff who travelled out on Sundays for afternoon tea in their new fangled automobiles amidst the splendour of this rugged part of Highland Perthshire.

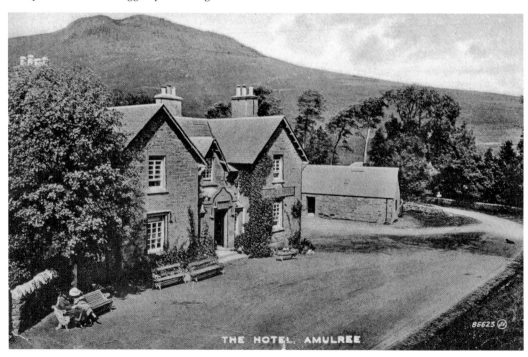

THE HOTEL, AMULREE

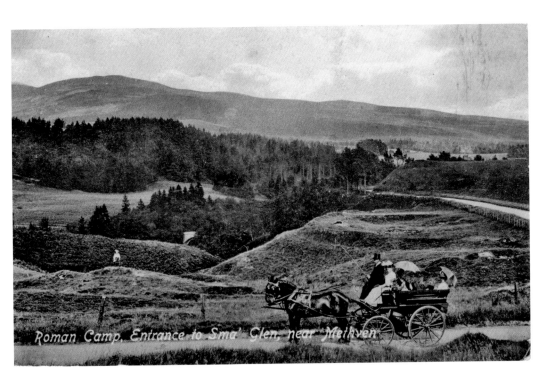

Roman Camp, Entrance to Sma' Glen, near Methven

Fendoch
The old Roman fort built as a 'glen blocker' in the first century AD as part of the Gask Ridge complex (the oldest roman frontier in Europe). It was a popular spot for Sunday afternoon charabanc trips prior to the First World War.

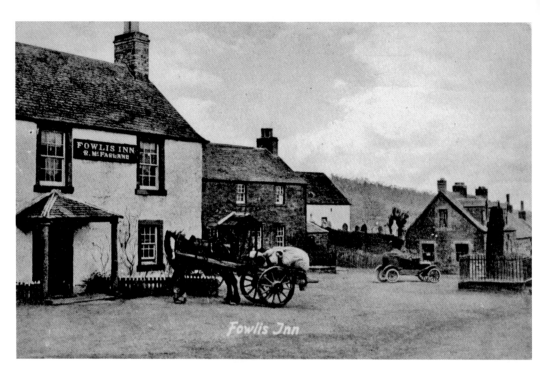

Fowlis Wester

Once a bustling village with its own annual Tryst and a regular market, the 'new' road to Perth in the lower ground south of Fowlis made it the peaceful place it is now. Gone is the inn, now a private residence, and the standing stone in the square is a replica with the original safely ensconced in the adjoining church to protect it from the eroding atmosphere.

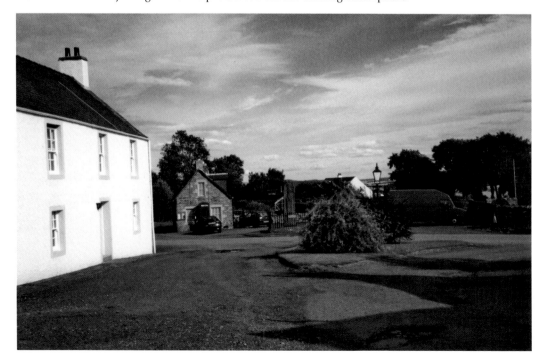

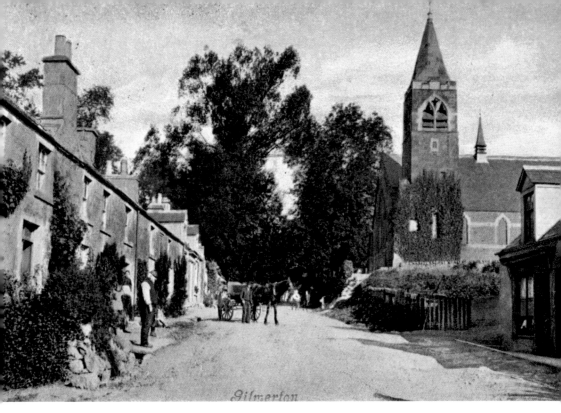

Gilmerton Highland Road

When the present Perth Road was constructed Gilmerton arrived as a village and soon outgrew nearby Monzie. Highland Road leads to the Sma' Glen and onto Aberfeldy or Dunkeld. The Free Church built in 1869 is now a house.

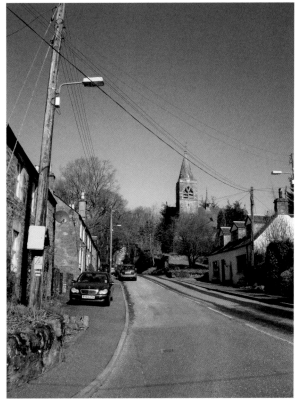

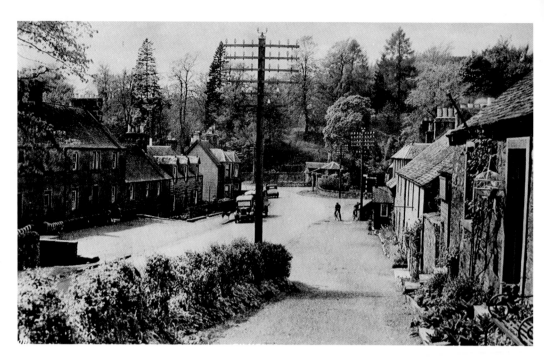

Gilmerton looking West

Perhaps because it sits astride the main A85 Crieff to Perth Road, Gilmerton has lost much of the peaceful charm of yesteryear as the volume of traffic rapidly increases. Despite a considerable number of new houses being erected in the 1960s and a rise in population, its only shop and post office closed some years back.

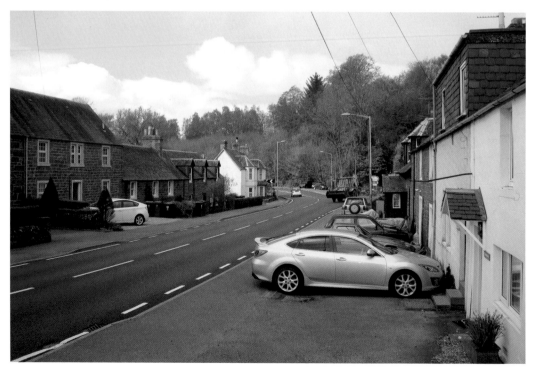

Braco, Old Free Kirk
The view to the north show the solitary steeple of the Free Kirk, a permanent reminder of the fallouts that befell the Presbyterian Church in nineteenth-century Scotland. New housing to the west of the village has brought a sizeable influx of new residents and added greatly to the active community spirit.

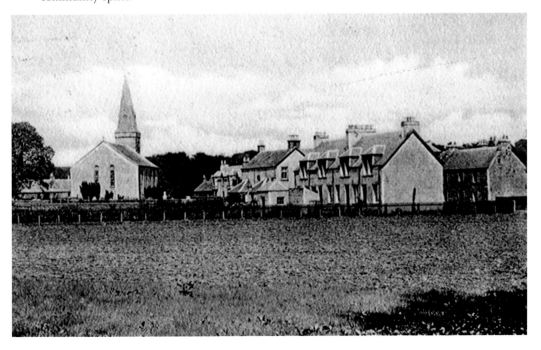

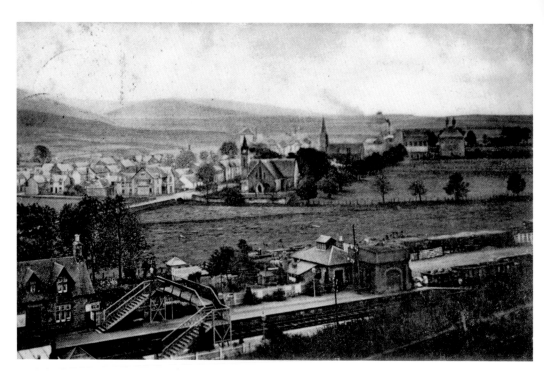

Blackford Station

There is a vigorous campaign (2010) to try and restore Blackford Station. Well placed beside the village and on the main Stirling to Perth line it would be a greatly beneficial asset. The increasing traffic for Highland Spring would surely be another plus point.

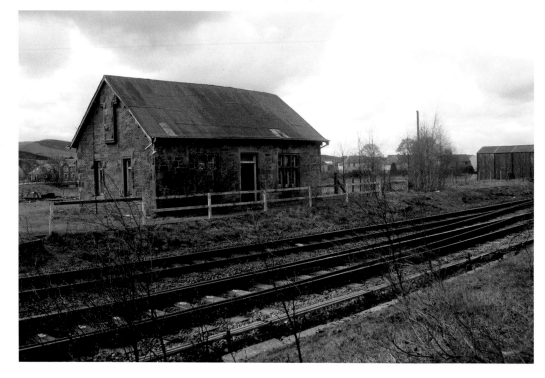

Blackford Brewery

Thomson's Brewery opened in Blackford in the late nineteenth century and was a major part of the area's economy for many years. The names of Sharp and Eadie also played an important part in local brewing. At one time there were three breweries in operation in Blackford. The old brewery is now part of the highly successful Highland Spring operation.

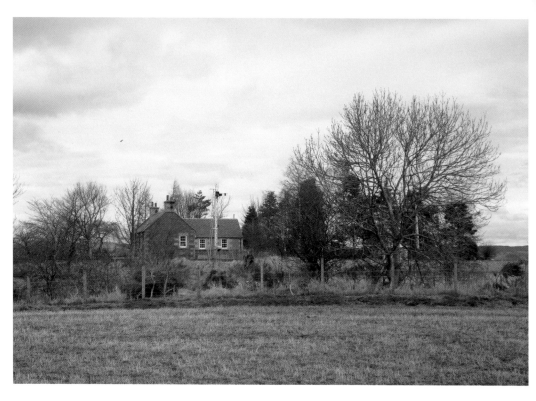

Auchterarder Station
Although the main line from Stirling to Perth runs past the old station it is no longer open to passengers. Similar to other local stations like Muthill and Methven, Auchterarder was located some distance from the town thus greatly reducing its viability for passenger usage.

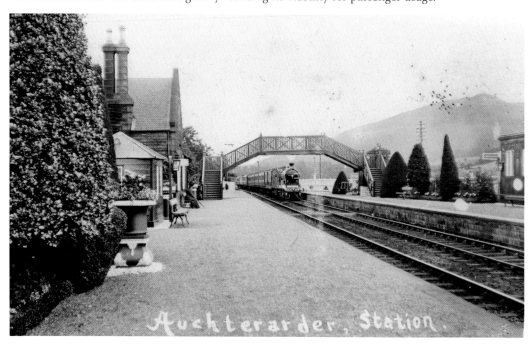

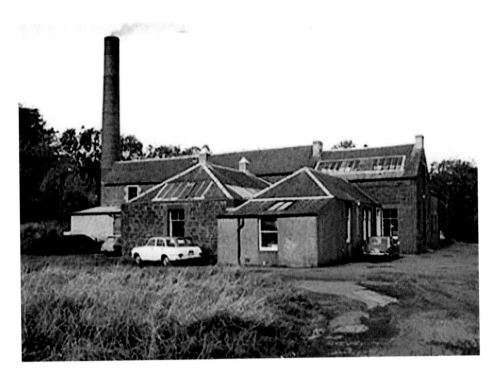

Auchterarder Mill

In the 1840s there were thirteen mills or 'manufactories' on the Ruthven Water in Auchterarder Parish. Halley's dominated as a cotton-weaving factory but it and the others succumbed to cheaper foreign competition. The site is now a small industrial estate giving needed employment to the town and surrounding area.

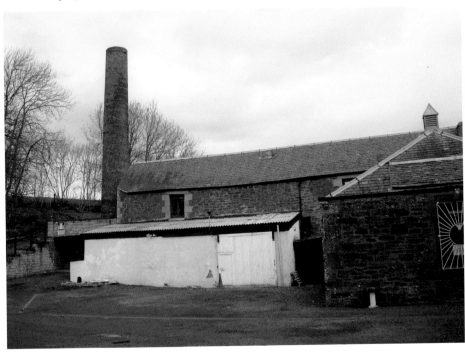

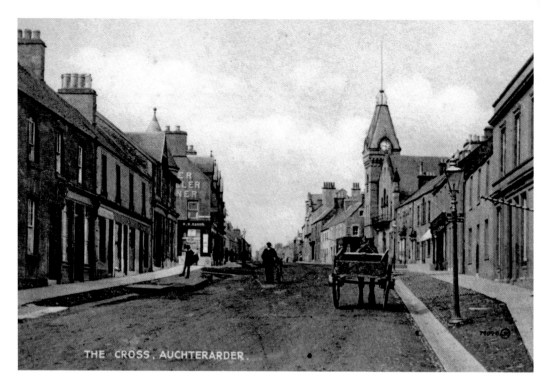

THE CROSS, AUCHTERARDER.

Auchterarder High Street, looking West

The early picture shows the open watercourse running down the side of the street and the numerous slabbed cross overs. James Vl described it to his English courtiers as the 'town with fifty draw bridges'. Auchterarder was Royal Burgh with an ancient heritage.

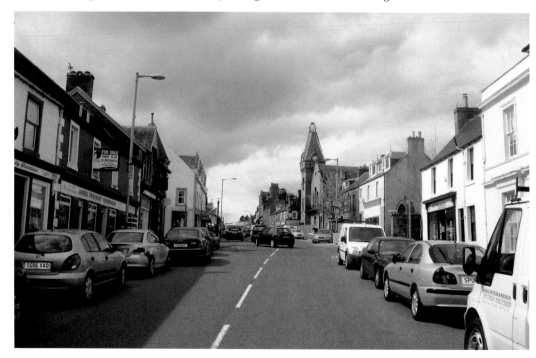

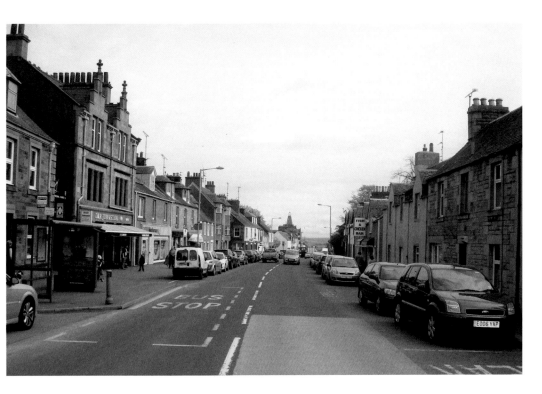

Auchterarder High Street looking East

The town once dependent on the self-employed handloom weavers and the subsequent power loom factories on Ruthven Water changed dramatically after the Second World War. The bourgeoning tourist trade boosted by nearby Gleneagles and golf has helped its prosperity.

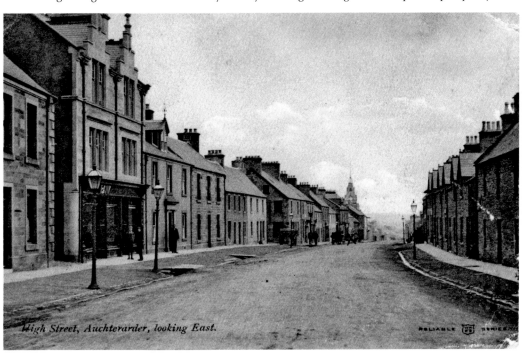

High Street, Auchterarder, looking East.

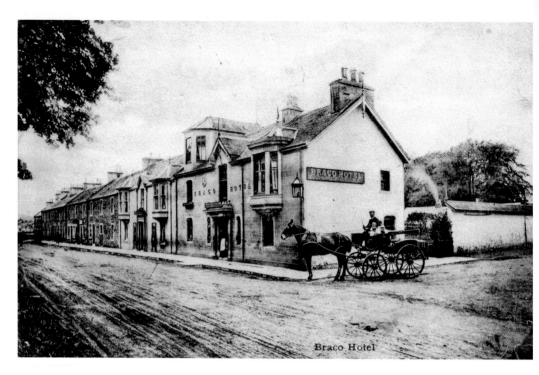

Braco Hotel

Braco Hotel
This old hostelry was once a popular base for those fishing the nearby waters of Carsebreck and the Rhynds. A recent name change to The Frog and Thistle defines the nationality of the new ownership!

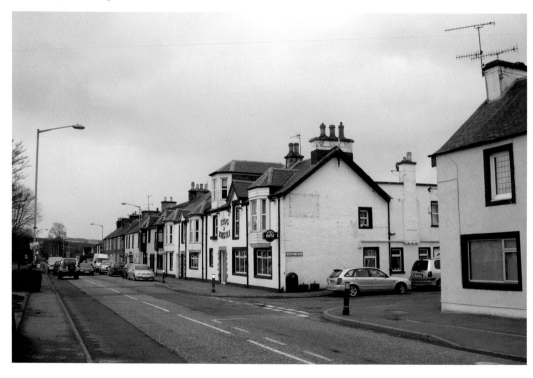

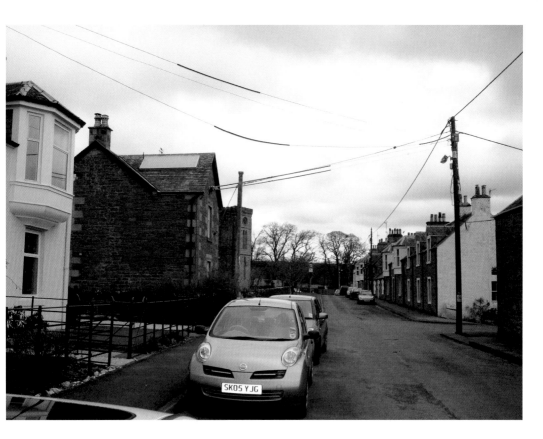

Braco Back Street
Still a comparatively quiet thoroughfare, note the loss of the steeple to the tower of the old Braco Free Kirk at the corner of Feddal and Church Streets. The rest of the building has been demolished.

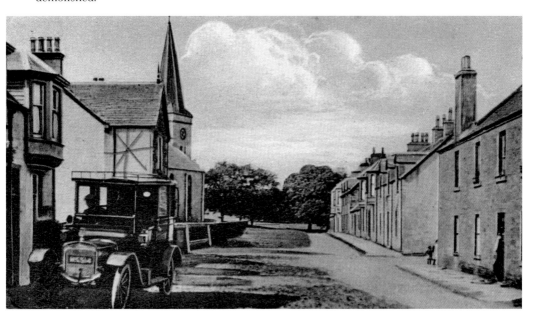

Acknowledgements & Dedications

It has been a fascinating study gathering together these pictures past and present. I have the good fortune to reside in a particularly attractive part of Scotland and within a community where there is a strong feeling of pride in their heritage. I would like to mention a number of people for their help and cooperation in enabling me to produce this book. To Crieff men Tom Handy and fellow author David Cowan, local photographer Lynn Duke, Brian Souter of Ochtertyre, Iain Somerville of Rannoch and Crieff and Alan and Vida Rose of Glentarf Comrie, I extend my sincere thanks.

In this book, I have endeavoured to illustrate graphically the changes that have occurred over the decades. It is important we pay attention to the future – and what is around that inevitable corner. Accordingly I dedicate this book to the younger members of my family who hold the future in their capable hands. With love and affection to Jasmine, Angus, Iona and Callum Mayall, Aimee and Fin MacDonald, Rowena and Callum Sharp and to our newest addition Max Roper.

CM

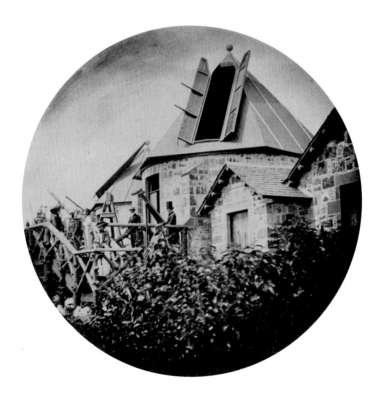